FROM THE FILMS OF

Harry Potter

CRAFTING WIZARDRY

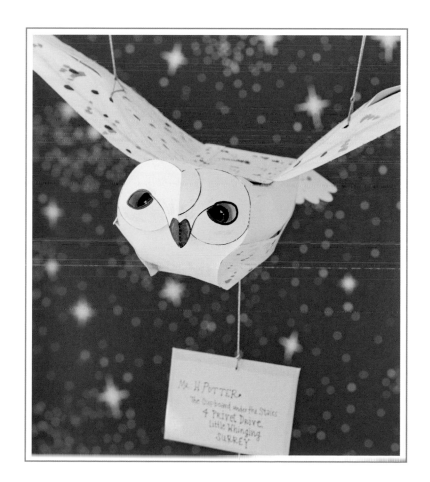

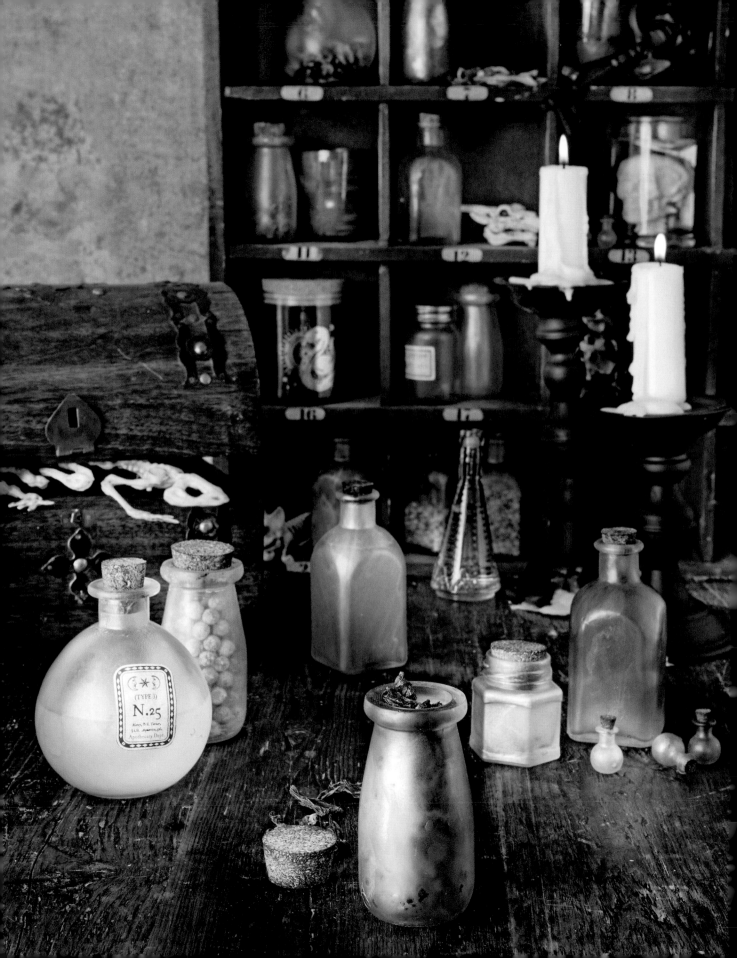

FROM THE FILMS OF

Harry Potter

CRAFTING WIZARDRY

THE OFFICIAL HARRY POTTER CRAFT BOOK

INSIGHT
EDITIONS

San Rafael • Los Angeles • London

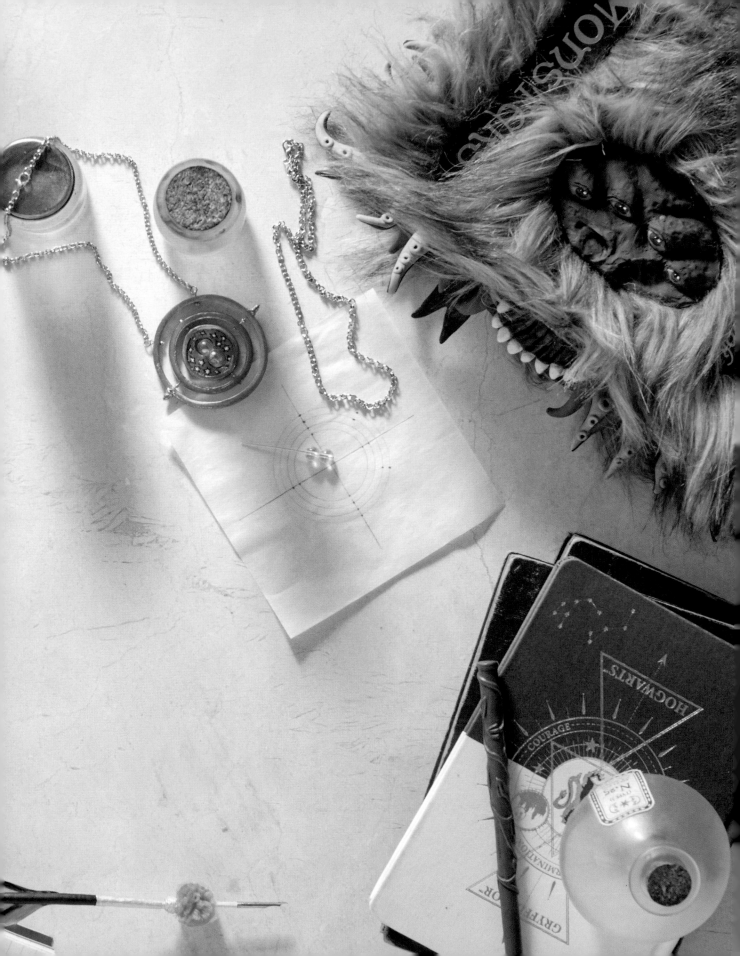

CONTENTS

Important! Many of the projects in this book require adult help and supervision. Children should only use tools that are appropriate to their age.

PROJECT SKILL LEVELS

⚡ BEGINNER

⚡⚡ EASY

⚡⚡⚡ INTERMEDIATE

⚡⚡⚡⚡ ADVANCED

⚡⚡⚡⚡⚡ COMPLEX

CHAPTER 1:
JOURNEY TO HOGWARTS

"THIS BOY'S HAD HIS NAME DOWN EVER SINCE HE WERE BORN. HE'S GOING TO THE FINEST SCHOOL OF WITCHCRAFT AND WIZARDRY IN THE WORLD AND HE WILL BE UNDER THE FINEST HEADMASTER THAT HOGWARTS HAS EVER SEEN, ALBUS DUMBLEDORE."

Rubeus Hagrid, *Harry Potter and the Sorcerer's Stone*

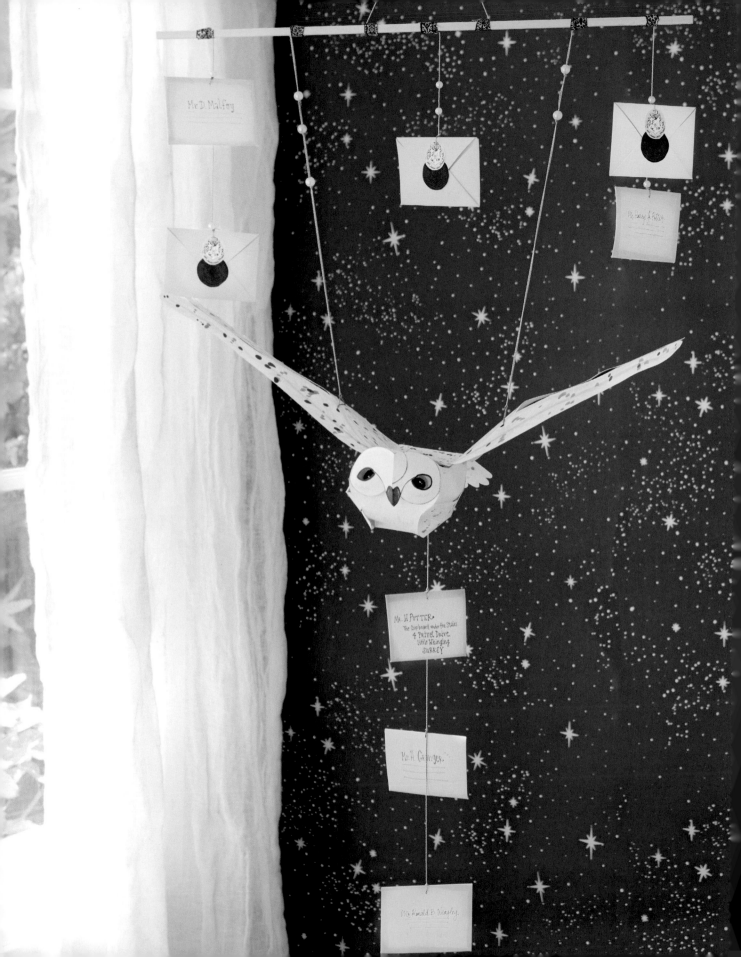

Hedwig and Hogwarts Acceptance Letters Papercraft Mobile

Designed by **MATTHEW REINHART**

SKILL LEVEL

In the wizarding world, letters, packages, and newspapers are delivered by owl post, and among the most important of the owls' responsibilities is to bring young witches and wizards their acceptance letter to Hogwarts School of Witchcraft and Wizardry. When Harry Potter takes in the mail one summer day, he finds a letter addressed to him from Hogwarts, but his uncle refuses to let him have it. More and more letters are brought each day by more and more owls leading up to a bombardment of acceptance letters that burst into the house.

For the movie, several owls were trained to carry and drop an envelope and letter that were handwritten by the graphics department and affixed with a wax seal for close-ups. Then, ten thousand single sheets of paper were printed with the Hogwarts seal and Harry's address in order to be light enough to fly through the air. Special effects supervisor John Richardson and his team installed devices in the chimney and behind the mail slot that could fling the papers out at a very rapid but controlled speed to ensure a blizzard of letters. Once Harry receives his letter, from Rubeus Hagrid, he is taken to Diagon Alley for his school supplies. As the letter allows for students to bring "an owl OR a cat OR a toad," Hagrid purchases a snowy owl for Harry (for his eleventh birthday), which Harry names Hedwig. Hedwig proves a loyal and loving companion for the young wizard. With this papercraft, you'll create your own Hedwig and surround her with a flurry of letters. With a tug on her string, Hedwig flaps her wings!

WHAT YOU NEED:
- Hedwig templates (pages 161–167)
- Scoring tool, such as a knitting needle or paper clip
- Ruler
- Cutting tools, such as scissors and utility knife
- Cardboard
- Glue
- String or yarn, thread, fishing line, ribbon, etc.
- Coins, for weight
- Pencil
- Dowel, branch, or stick to hang the mobile from

OPTIONAL:
- Markers or colored pencils
- Bone folder
- Decorative tape

1. Punch out the provided templates on pages 161–167.

2. Fold the template pieces on all the creased lines. Press firmly to make crisp folds.

3. This mobile will need some weight for stability. Use pieces A, B, and C as templates on cardboard to cut out 2 long slender pieces and 1 small rectangular piece. These will help balance the mobile.

4. Decorate template cutouts D, E, F, and G as desired. Feel free to get creative here. Give Hedwig some of her markings across these pieces. On H and I, draw Hedwig's eyes. Do not draw her eyes directly on G.

ASSEMBLING THE WINGS

1. Glue the wing tabs on piece E to the corresponding gray areas on the same piece. Allow to dry for a few minutes. Cut a long piece of string (at least 24 inches—longer is better because you can always trim excess string later), and insert through both wing holes from the top side down.

2. Loop back the string, and pull it back up through the opposite hole into which it was initially inserted. Both ends of the string should be on the top side of the wing. Don't pull the string too taught.

3. Glue one of the cardboard wing weights to the underside of the wing underneath the string loops, making sure not to get glue on the strings. Pull the strings to tighten them flat against the cardboard.

4. Tightly knot the string on the top side of the wing. Leave the ends long for later assembly. Repeat steps 1 through 4 for the second wing, piece F. Set aside.

ASSEMBLING THE BODY

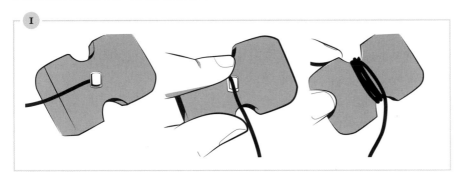

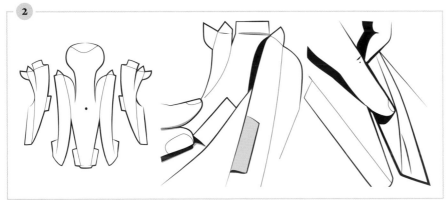

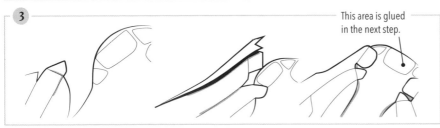

This area is glued in the next step.

1. Cut a length of string at least 24 inches long. Dab glue on the center of the cardboard weight (cut from piece C), and adhere one end of the string to the glue dot. Wrap the string around the weight and set aside for later assembly.

2. Use the gray-shaded areas as a guide to glue all the tabs on pieces J and K to the sides of piece G, the body. Piece K should be glued to the left side of piece G, and piece J on the right. Let dry for a few minutes.

3. Start to glue down the tabs connecting the sides of the body to the side of the head on piece G, using the shaded areas as your guide. The glue points are numbered so that you can glue each numbered tab to the corresponding numbered area.

NOTE: The tabs on the sides and top of the head can be a little tricky to glue into place. You may need to gently reach inside and press the tabs from both sides to get them to hold.

1

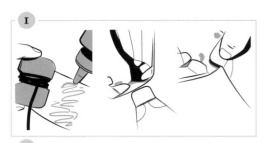

2

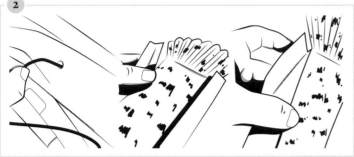

3

4

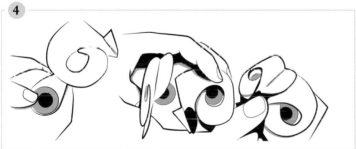

5

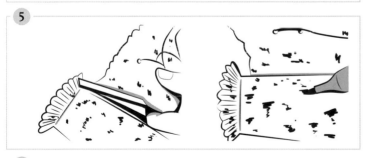

6

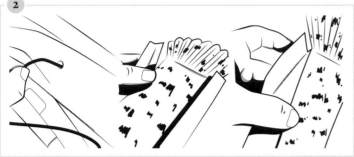

1. Unravel the string on your center weight (cut from piece C), and glue the weight to the corresponding gray shaded area on piece D. Next, finish gluing the head closed by adhering the top of piece D to the last shaded area on the inside of the head.

2. Make sure to insert the end of the string on the center weight through the hole in the underside of Hedwig before gluing the entire top piece into place.

3. Finish gluing the top body piece (D) into place by following the gray shaded areas as guides.

4. Glue pieces H and I (the eye tabs) to the front of the head section of piece G. Flip the face pieces (H and I) to join in the middle, and glue the appropriate tabs, using gray-shaded areas as guides.

5. Glue the wings (E and F) to the top of the back (D), lining up the square ends of the tabs with the base of the tail piece (D). Add more marker detail if needed.

6. If desired, glue the wing weight templates (A and B) over the cardboard to make them look less obvious. Glue or tape coin(s) to the wing weights, just to the outer side of the string.

NOTE: A single large coin on each wing works well, but 2 to 3 smaller coins could also be used if that's what available.

FOLDING ENVELOPES

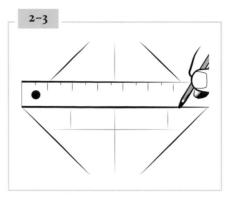

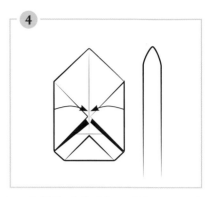

1. Cut as many pieces of paper as envelopes desired into four ½-inch squares. Place the pieces of paper on a flat surface angled like a diamond.

2. Using a ruler, draw a line from the left corner to the opposite right corner. Do the same for the remaining 2 corners. Mark the center as your guide.

3. At ¾ inch below your horizontal center line, draw a parallel line across. Score this line, and fold the bottom corner to that line.

4. Fold the left side, and then repeat with the right side.

TIP: Use a bone folder to help make your folds sharper.

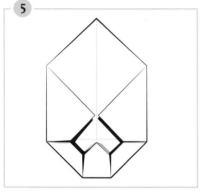

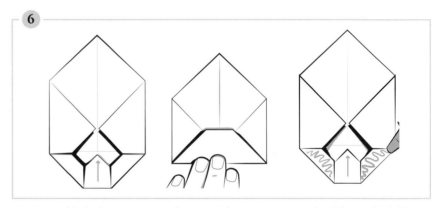

5. Fold the bottom left corner up to form a trapezoid shape. Repeat with the bottom right corner.

6. Fold the bottom up on the center line. Your paper should now look like an envelope with an open top. Glue the 2 trapezoidal sides to secure.

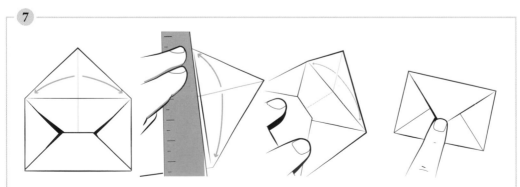

7. Using a ruler, draw a line from 1 folded corner to the other. Score along that line, and fold along that line to complete the envelope shape.

DECORATING THE HOGWARTS LETTERS

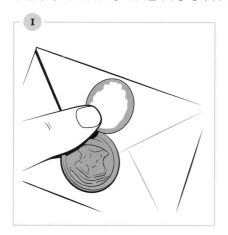

1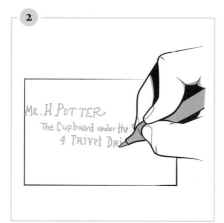

3

1. Use the provided stickers for the Hogwarts wax seal, and adhere into place on the envelopes.

2. Decorate the front of the envelopes with Harry Potter's Privet Drive address:

Mr. H. Potter
The Cupboard Under the Stairs
4 Privet Drive
Little Whinging
Surrey

3. Poke a hole through the top center of the envelope to insert string.

ASSEMBLING THE MOBILE

2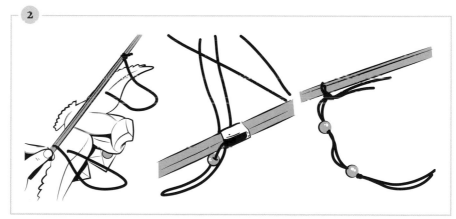

1. Tie 2 to 3 letters from the string on the underside of Hedwig.

2. Attach the strings tied to the wings onto your stick. If the string doesn't tie tightly (like fishing line or anything slippery), use a dab of glue or decorative tape to hold it in place. Feel free to add beads or embellishments as desired.

3

NOTE: You have the freedom to use as many or as few letters as you like, but there needs to be at least one on the underside of Hedwig to pull. Also note that adding many letters can add extra weight, so make sure the mobile is securely tied and hung.

3. Secure the knots on the letters with a small dab of glue. Hang as many letters as desired from the dowel. Tie a piece of string into a loop in the center of the stick to hang the mobile from.

4

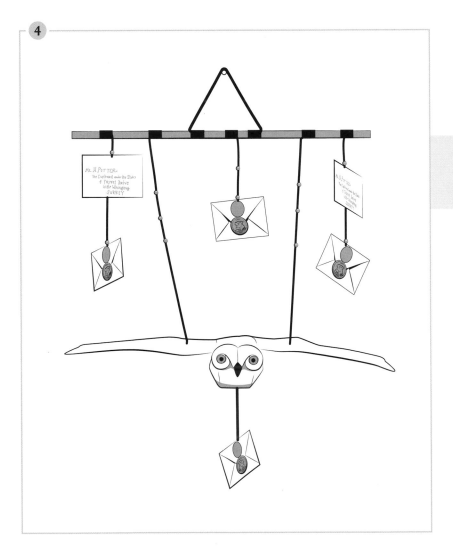

4. Be sure to center Hedwig on the mobile, and tie the wings evenly so she doesn't tilt to one side. Otherwise she'll wobble around unevenly when you pull on the bottom string.

NOTE: Tugging lightly on the bottom string will make Hedwig flap her wings!

"DAD, LOOK! HARRY'S GOT A LETTER!"

Dudley Dursley, *Harry Potter and the Sorcerer's Stone*

Behind the Magic

Though Hedwig is a female in the story, she was played by several male snowy owls in the films. Males have fewer dark markings than females and are smaller, which made them easier for Daniel Radcliffe (Harry Potter) to carry.

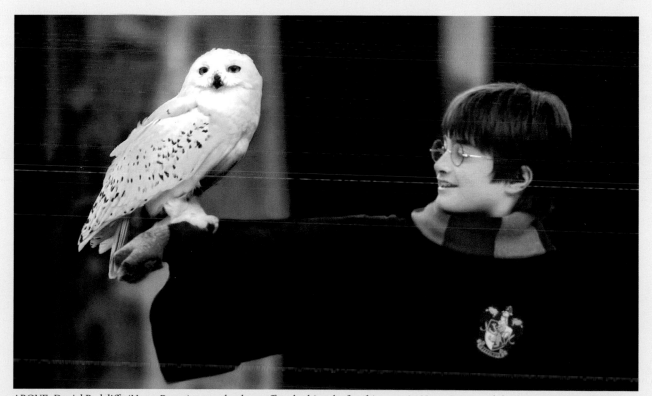

ABOVE: Daniel Radcliffe (Harry Potter) wore a leather cuff under his robe for this scene in *Harry Potter and the Sorcerer's Stone* where Hedwig perches on his arm.

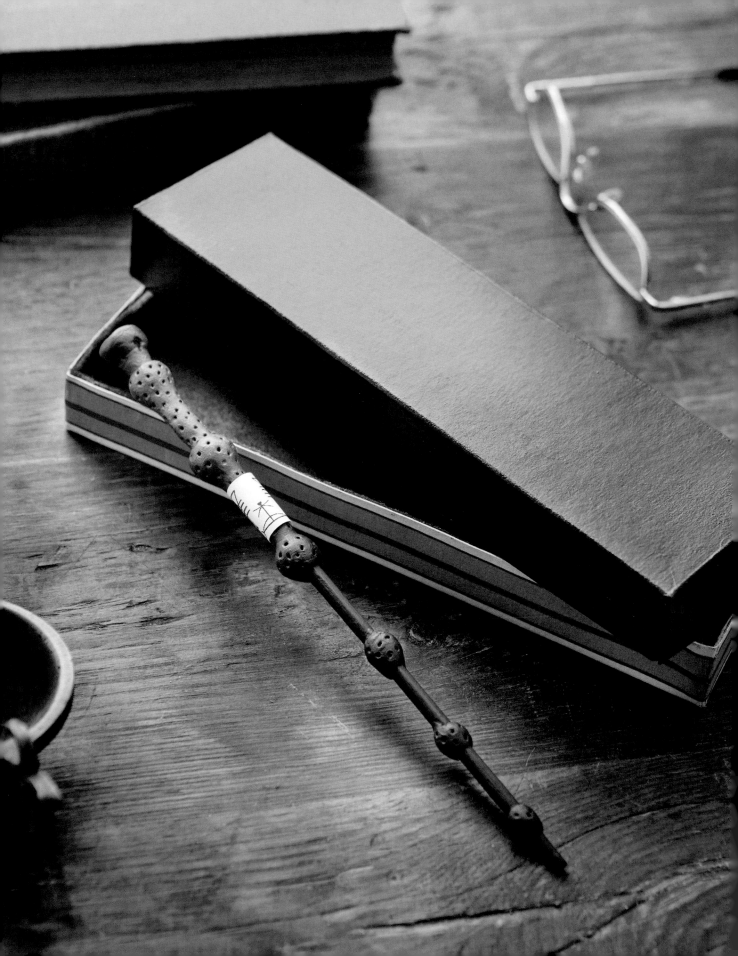

Elder Wand and Ollivanders Wand Box

Designed by **JILL TURNEY**

SKILL LEVEL ⚡

Once Harry Potter receives his acceptance letter to Hogwarts, he needs to get a wand: an instrument that channels the user's magic. Harry finds his at Ollivanders, a shop in Diagon Alley that has been selling wands since 382 BC. Though many wands in the films appear to be simple sticks, they are fashioned from rare woods with interesting shapes, and decorated with crystals, bands, or alchemic symbols.

Ollivanders has shelves and shelves of boxes with wands waiting for their wizards. In fact, seventeen thousand boxes were created for *Harry Potter and the Sorcerer's Stone*, each box individually decorated with handmade labels featuring numbers, runes, and the material that makes up the wand's core (phoenix feather, Thestral tail hair, dragon heartstring). The wand for this craft is based on the most powerful wand of all: the Elder Wand, which is in the possession of Hogwarts Headmaster Albus Dumbledore. When the designers and propmakers first fashioned Dumbledore's wand, they had no idea how important that wand would be to the story!

ELDER WAND

WHAT YOU NEED:
- 1 chopstick (no longer than 9 inches)
- White air-dry clay
- Toothpick
- Dark brown acrylic paint
- Paintbrush
- Elder Wand label (included in back of book)

NOTE:
- If your chopstick is too long, use a nail file or sandpaper to shave it down to 9 inches. This will allow it to fit inside the Ollivanders box.

OLLIVANDERS WAND BOX

WHAT YOU NEED:
- Empty standard size rectangular tissue box (9-by-3½-by-4¾-inch)
- Ruler
- Pencil
- Scissors
- Spoon
- Craft glue
- Yardstick (or 24-inch ruler)
- ¾-inch-wide masking tape
- Purple, light brown, and cream acrylic paint
- Paintbrush
- Red pen or marker
- 9-by-12-inch sheet of purple craft felt
- Ollivanders logo sticker (included in back of book)

OPTIONAL:
- Binder clips

MAKING THE ELDER WAND

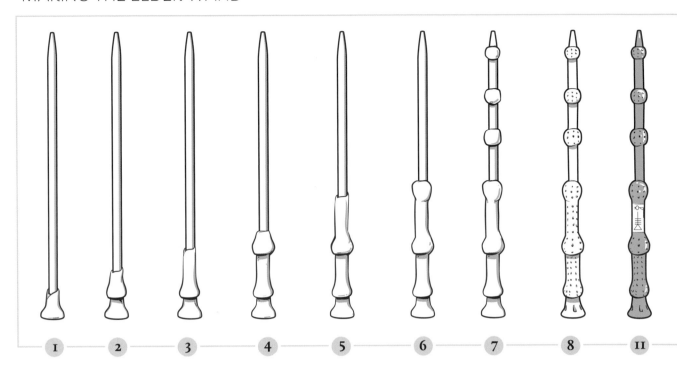

1 — 2 — 3 — 4 — 5 — 6 — 7 — 8 — II

1. Add a small bit of clay all around the wide end of your chopstick and form it into a bell shape.

2. Mold another bell shape above the first.

3. Add a thin layer of clay to fill in an inch above the second bell. Blend the clay in with the second bell.

4. Mold another bell shape above the clay you added in step 3.

5. Add another thin layer of clay to fill in a 1-inch area above the third bell shape.

6. Now add a round bead of clay above the 1-inch area and blend it in with the clay beneath it.

7. Add 3 more beads of clay along the bare wood chopstick.

8. Carve teardrop shapes with the toothpick around the bell shape at the bottom and poke holes in the rest of the clay.

9. Put your wand in a safe place to dry overnight. Put your unused clay in an airtight container.

10. When your wand is dry, paint it with the dark brown acrylic paint. Let the paint dry.

11. Apply the Elder Wand sticker included in the back of this book between the bead and the bell.

TIP: If you're having trouble filling the holes in with paint, dip the tip of a toothpick in the paint and poke it in the holes.

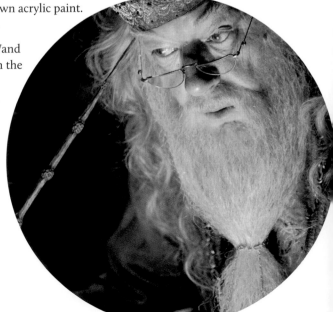

MAKING THE WAND BOX BOTTOM

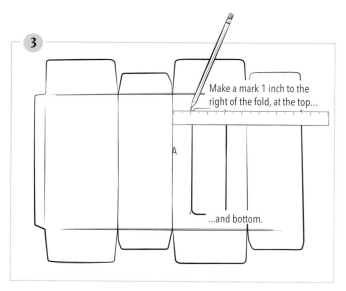

1. Break down the tissue box so it's one big flat piece of paperboard. Remove the sheet of plastic.

2. Lay it on a flat surface with the printed side down.

3. Measure 1 inch from the short side fold (A). Make a pencil mark at the top and bottom.

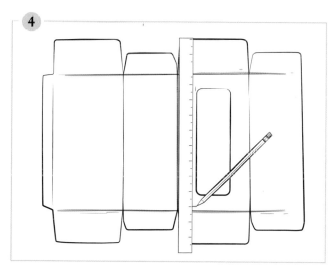

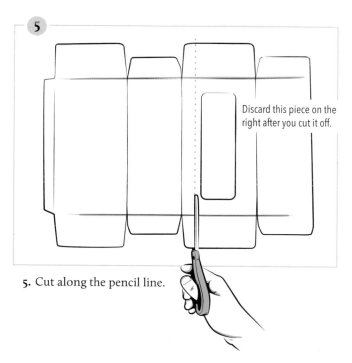

4. Align your ruler along those two marks and draw a vertical line the full length of the box.

5. Cut along the pencil line.

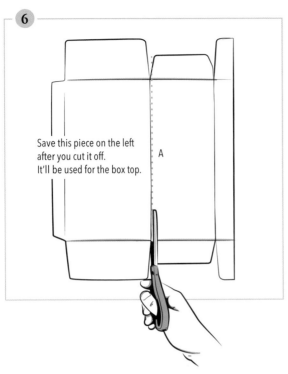

6. Cut along the fold line on
the opposite side (A).

Save this piece on the left
after you cut it off.
It'll be used for the box top.

A

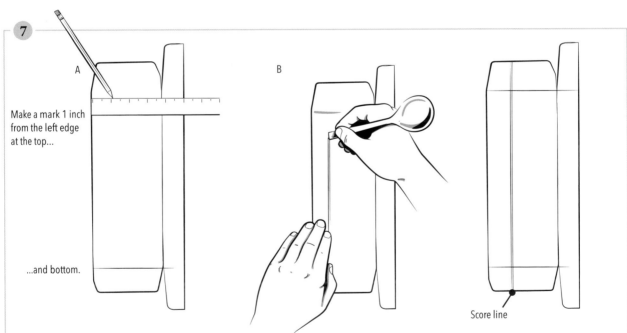

A

Make a mark 1 inch
from the left edge
at the top...

...and bottom.

B

Score line

7. Make pencil marks 1 inch in from
the left side of the board at the top
and bottom (A).

Align your ruler along the marks.

Make a score line by running the
flat end of a spoon handle along the
edge of the ruler. Press hard with
the end of the spoon (B).

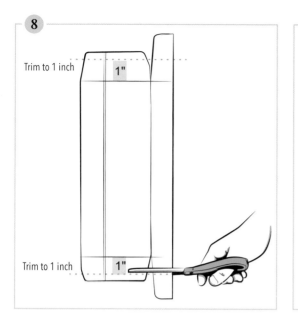

8

Trim to 1 inch 1"

Trim to 1 inch 1"

9

Cut slit here

A

B

Cut slit here

8. Trim the top and bottom flaps so they're 1 inch tall.

9. Cut slits at the top (A) and bottom (B) of your score line.

10. Assembling the box: Turn the board over so the printed side is facing up (A). Fold the two long sides up toward you (B). Then fold the small tabs in toward each other (C). Add glue to the top and bottom flaps (D). Fold them up to attach them to the small tabs (E). Use your fingers or binder clips to hold the pieces together until the glue dries.

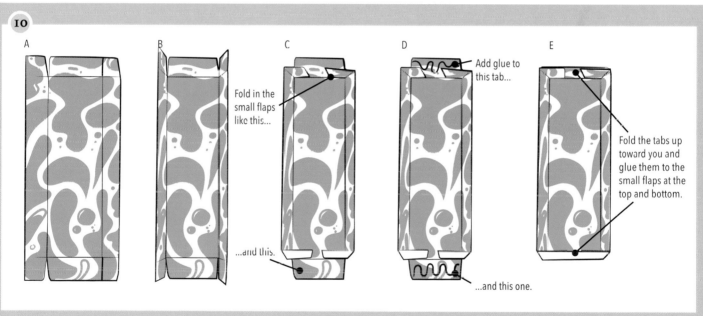

10

A B C D E

Fold in the small flaps like this...

...and this.

Add glue to this tab...

...and this one.

Fold the tabs up toward you and glue them to the small flaps at the top and bottom.

11

11. Turn the box over and paint all the outer sides with cream-colored acrylic paint. If the paint looks splotchy after it dries, add a second coat.

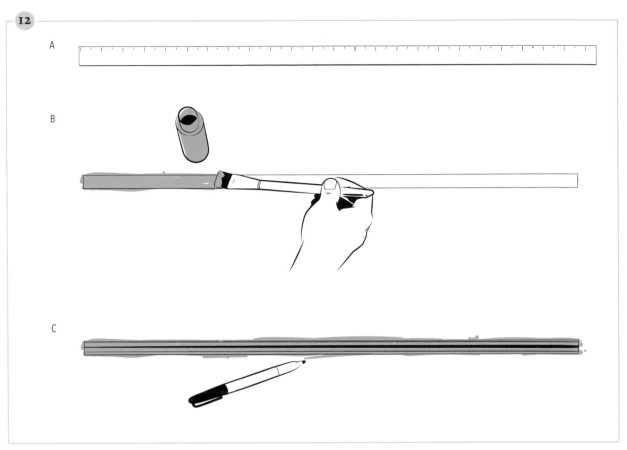

A

B

C

12. Making the box stripe: For this part of the project, you're going to want a surface you don't mind getting paint on. On your surface, roll out a 24-inch strip of masking tape along the edge of a yardstick (A). Paint the tape light brown (B). Wait for it to dry. With a red pen and a yardstick, draw thin horizontal red lines along the top and bottom edges of the tape, and a double thick line in the center (C).

13. Gently peel the tape off the surface and wrap it around the middle of the cream-painted box. Overlap the tape ends for a quarter inch where they meet, and then trim off any excess tape.

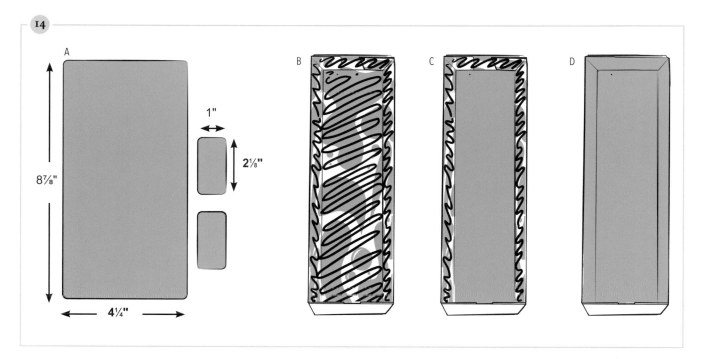

14. Adding felt to the bottom box: Cut one piece of purple felt 8 ⅞-by-4¼-inch. Cut two pieces 2⅛-by-1 inch (A). Squirt glue along the interior long sides and bottom of your box (B). Glue the large piece of felt inside the box, pushing the felt into the corners so it's glued down nice and flat (C). Glue the 2 small pieces of felt to the remaining short sides (D). Now your box bottom is complete!

MAKING THE BOX TOP

1. Grab the paper board piece you saved from step 6 of the box bottom instructions.

2. Lay the piece, unprinted side up, on a flat surface. Trim off the right flap.

3. Measure 1⅛ inch in from the right side and left side and make marks at the top and bottom.

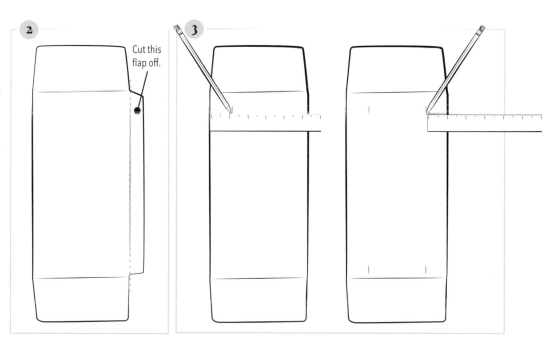

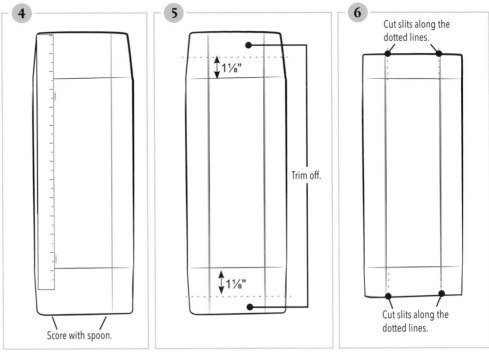

4. Lay your ruler along the pencil marks on the left. Grab your spoon and, with its handle, make score lines by pressing down hard along the edge of the ruler. Repeat on the right side.

5. Trim the top and bottom flaps so they measure 1⅛ inch, the same as the long flaps.

6. Cut slits as shown.

Score with spoon.

1⅛"

Trim off.

1⅛"

Cut slits along the dotted lines.

Cut slits along the dotted lines.

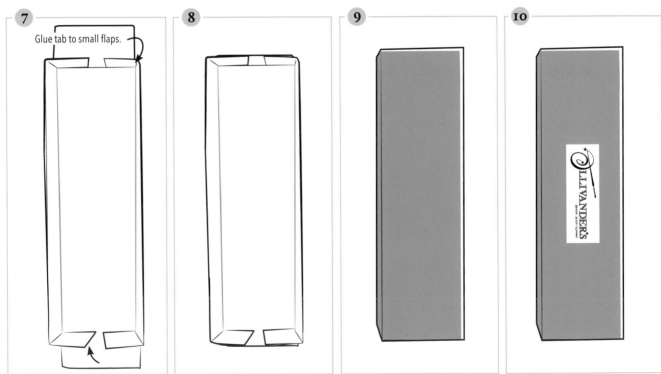

Glue tab to small flaps.

OLLIVANDER'S

7. Turn the box over. Fold the long ends up toward you and the small flaps in toward the center.

8. Glue the top and bottom tabs to the folded-in small flaps.

9. After the glue dries, paint the whole box with purple acrylic paint.

10. Add an Ollivanders wand box label (sticker included in the back of this book).

"I'M JUST SAYING, THAT'S THE ELDER WAND. IT'S THE MOST POWERFUL WAND IN THE WORLD. WITH THAT, WE'D BE INVINCIBLE."

Ron Weasley, *Harry Potter and the Deathly Hallows – Part 2*

Behind the Magic

For the films, the Elder Wand was made from a piece of English oak, with a bone inlay at the handle decorated with runes.

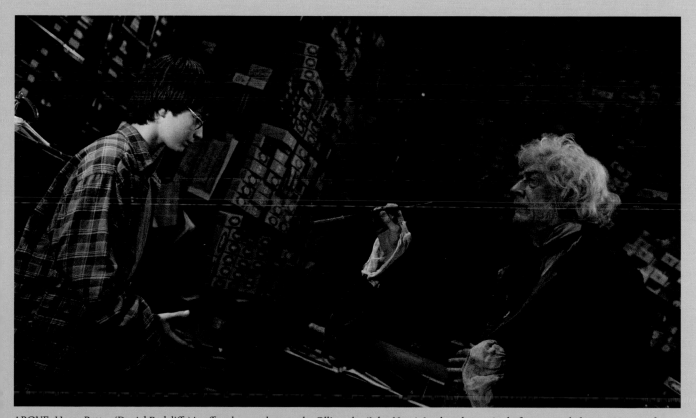

ABOVE: Harry Potter (Daniel Radcliffe) is offered a wand to test by Ollivander (John Hurt). It takes three tries before a wand chooses Harry (after all, it is the wand that chooses the wizard!).

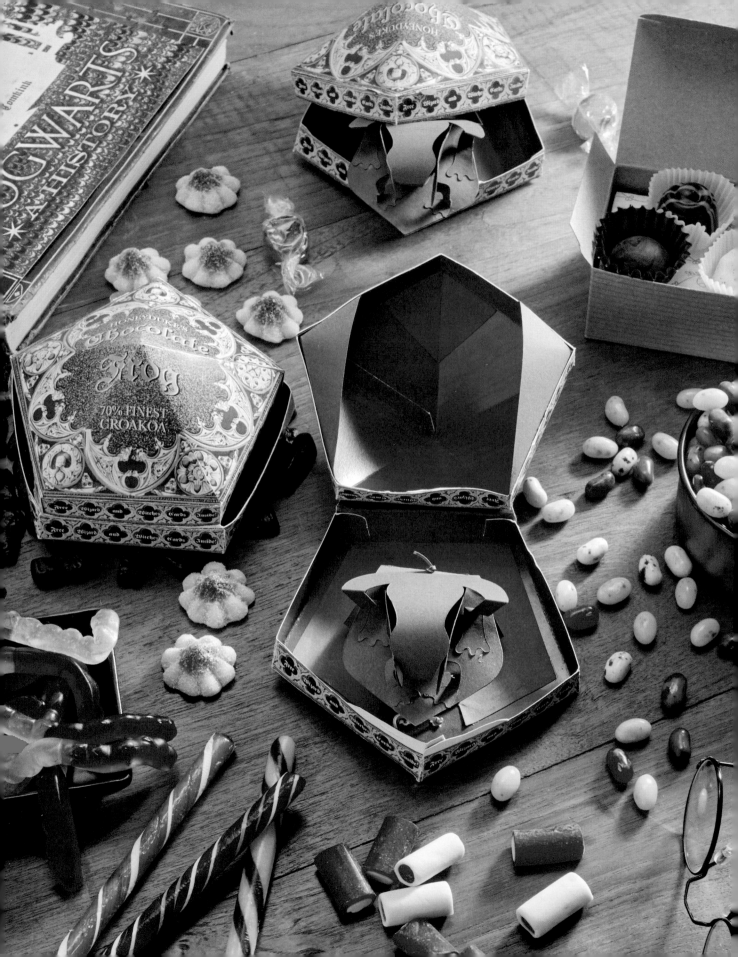

POPPING CHOCOLATE FROG

Designed by **MATTHEW REINHART**

SKILL LEVEL ⚡

Harry Potter meets one of his best friends, Ron Weasley, on the Hogwarts Express, the train that takes these first-year students to Hogwarts School of Witchcraft and Wizardry in *Harry Potter and the Sorcerer's Stone*. Harry is sitting alone in his compartment when a ginger-haired boy asks to join him—all the other compartments are full. Harry doesn't mind at all! Once they've introduced themselves, and after Ron catches a glimpse of Harry's lightning-bolt-shaped scar, the trolley witch comes by with her cart loaded with wizarding confections, including a large display of Chocolate Frogs. Harry's unfamiliar with the candy and worries that real frogs are used, but Ron assures him it's just a spell. Once Harry opens the box, the frog-shaped sweet jumps onto the half-open window and then makes its escape, blowing away in the wind.

Chocolate Frogs are sold in every sweet shop in the wizarding world: Honeydukes in Hogsmeade has a column of Chocolate Frog boxes arranged on one wall. Per the label created by the film's graphics department, 70 percent of a Chocolate Frog contains the finest "croakoa"—a mash-up of croak and cacao, aka cocoa bean, the seed from which chocolate is made. While most Chocolate Frogs can make only one good jump, this papercraft Chocolate Frog will have lots of leaps in it thanks to a clever rubber band mechanism.

WHAT YOU NEED:
- Chocolate Frog templates (pages 169–173)
- Cutting tool, such as a craft blade or utility knife
- Glue
- Rubber band
- Ruler
- Scissors

OPTIONAL:
- Tweezers
- Markers, glitter, decorative tape, sequins, etc., for decoration
- Blue construction paper

GETTING STARTED

1. Punch out the Chocolate Frog templates from pages 169–173.

2. Fold the template pieces on all the creased lines. Press firmly to make crisp folds.

ASSEMBLING THE LID

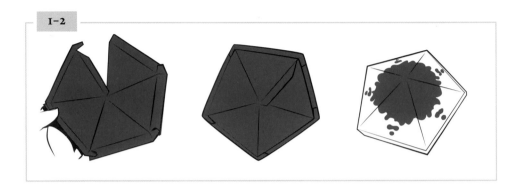

1. On piece A, glue the largest tab to create a pointed lid.

2. Glue all small tabs on piece A to close the sides.

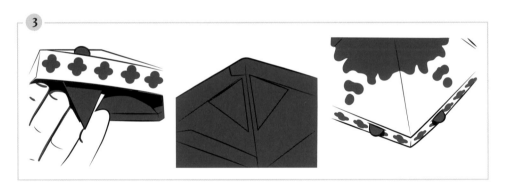

3. Glue down pieces I and J to the inside of the lid with round tabs sticking through the holes on the lid. This will help the box stay closed later.

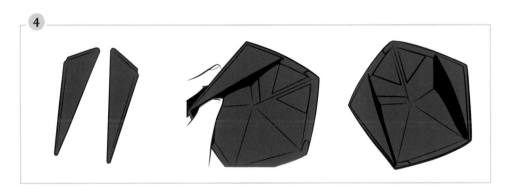

4. Glue down the supports (pieces G and H) to the inside of the lid below pieces I and J. This will help hold the frog in place when the box is closed and can hold a Famous Wizard Card, too.

5. Glue all small tabs on piece K to bring the sides of the box bottom together, using the darkened shaded areas as guides.

ASSEMBLING THE POP-UP

I-2

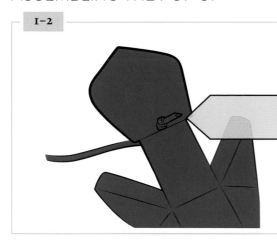

1. Cut a large rubber band, and insert one end into the hole at the back of the frog base piece (C).

 TIP: Cutting the rubber band at a slanted angle will help feed it through the hole.

2. Tie a secure knot (don't pull too hard, or the band might snap), using tape if necessary to hold it in place. Leave the other end of the rubber band loose.

NOTE: Some steps might seem out of order but need to be done in a specific way. Here, the rubber band has to be inserted before the frog is assembled; otherwise the frog would get in the way.

ASSEMBLING THE FROG

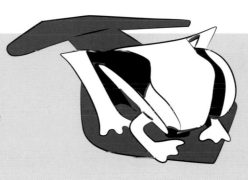

1. Glue the bottom of the frog (B) to the base (piece C), using the shaded area as a guide. The frog will be belly-up. Do not glue the feet yet.

2. Pull the head of the frog forward toward the feet, and glue the front tab underneath the frog to create the body.

3. Glue down the frog feet, using the shaded areas as guides.

ASSEMBLING THE POP-UP (CONTINUED)

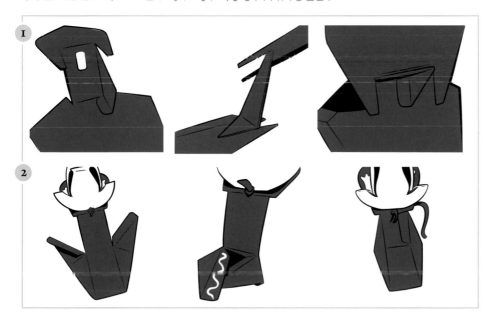

1. Glue down the indicated support piece (D) to the pop-up base (F), lining up the holes and using the shaded areas as a guide.

2. Glue down the support tabs on the frog base piece (C), then glue the entire piece to the larger base insert (F). Glue the underside of the frog base piece to the top of the larger base insert.

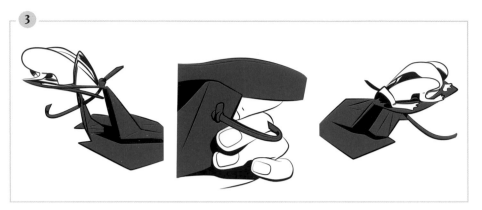

3

3. Glue the support piece (E) to the underside of the bottom (K). Insert the loose end of the rubber band down and back through the holes.

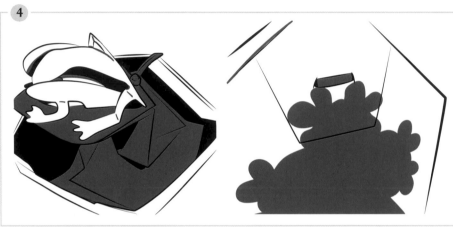

4

4. Securely tie the end of the rubber band in place. There needs to be a lot of tension in order for the frog to pop forward with a lot of force, but be careful not to break the rubber band.

NOTE: Because it's a small space, using tweezers may be helpful for pulling the rubber band as needed.

5. Finally, glue the entire mechanism (F) into the base (K).

FINISHING TOUCHES

1. Glue the top lid to the base, using the shaded areas as guides.

2. If you like, create a Famous Wizard Card to insert into the lid of your Chocolate Frog box. To do so, cut a pentagon out of construction paper big enough that it won't fall out of the lid, but not so big that it can't easily be taken in and out. Then you can draw and decorate any famous witch or wizard you like!

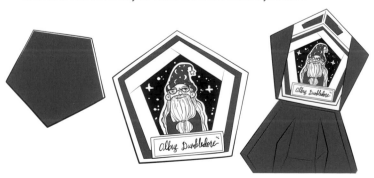

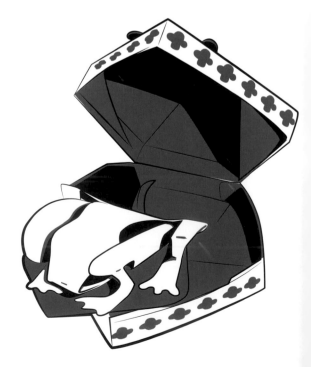

"OH, THAT'S ROTTEN LUCK. THEY'VE ONLY GOT ONE GOOD JUMP IN THEM TO BEGIN WITH."

Ron Weasley, *Harry Potter and the Sorcerer's Stone*

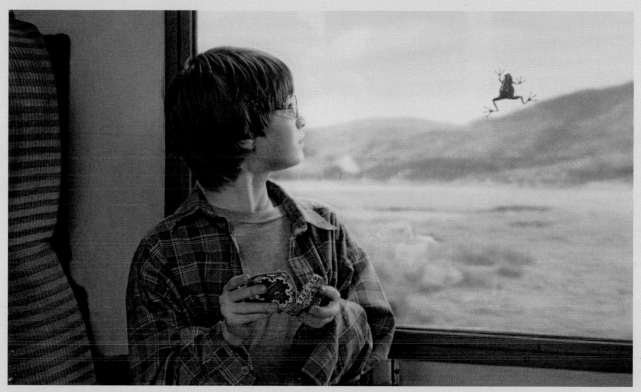

ABOVE: Harry Potter (Daniel Radcliffe) watches his Chocolate Frog head for freedom in *Harry Potter and the Sorcerer's Stone.*

BEHIND THE MAGIC

When the young actors filmed their scene inside the train compartment, *Harry Potter and the Sorcerer's Stone* director Chris Columbus remembers that Rupert Grint (Ron) "thought this was the greatest day of his acting career, because we were letting him eat chocolate and candy all day."

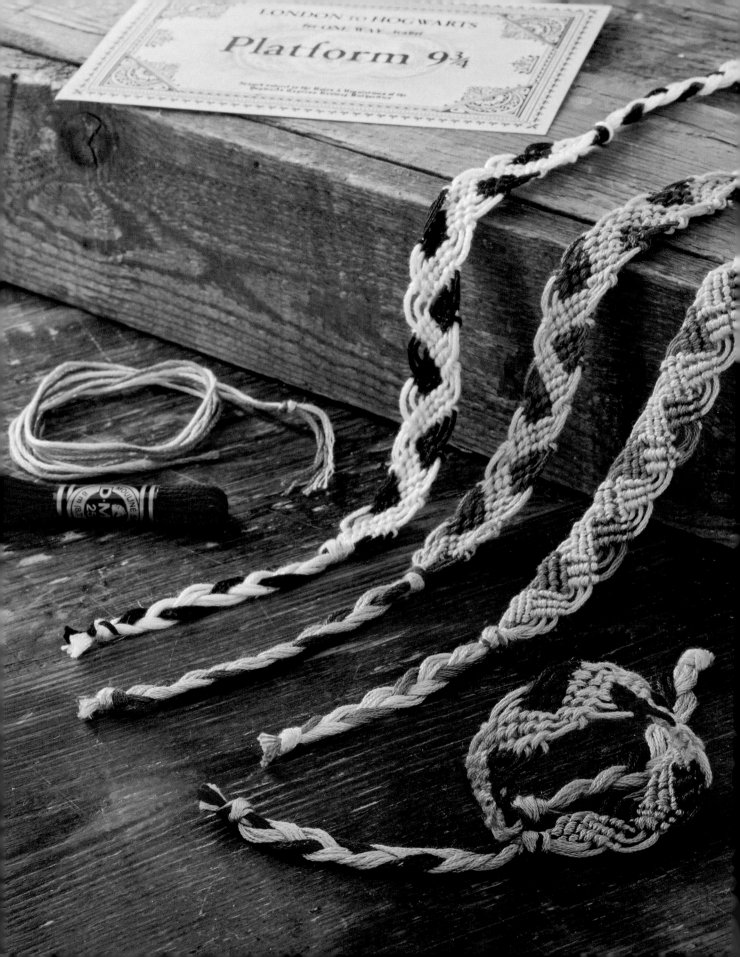

HOGWARTS HOUSE PRIDE BRACELETS

Designed by **JILL TURNEY**

SKILL LEVEL ⚡⚡

When Harry Potter and the other first-year students arrive at Hogwarts in *Harry Potter and the Sorcerer's Stone*, they are met by Professor Minerva McGonagall, who informs them that before they can join their classmates in the Great Hall, they will be Sorted into one of four houses: Hufflepuff, Ravenclaw, Gryffindor, or Slytherin. Each house has its own dormitory and Quidditch team, and competes for the annual House Cup by winning points for triumphs or losing points for transgressions. And each house has its own house colors: Gryffindor's colors are scarlet and gold; Slytherin's are green and silver; Ravenclaw's are blue and silver; and Hufflepuff's, yellow and black. These are displayed on student robes, scarves, and Quidditch uniforms. Now you can declare your own Hogwarts house pride with these vibrant macramé bracelets. Macramé is the art of knotting cord or string in patterns to make decorative pieces. Know that the knots used here are almost as easy as tying your own shoelaces. Other than the materials, the only tools you need are your own hands.

WHAT YOU NEED:
- Skeins of embroidery floss, one for each color in your Hogwarts house
- Measuring tool (tape measure or yardstick)
- Scissors
- Masking tape

OPTIONAL:
- Toothpick

1. Measure and cut 3 lengths of 32 inches of dark-colored floss.

2. Measure and cut 6 lengths of 32 inches of the lighter color of floss.

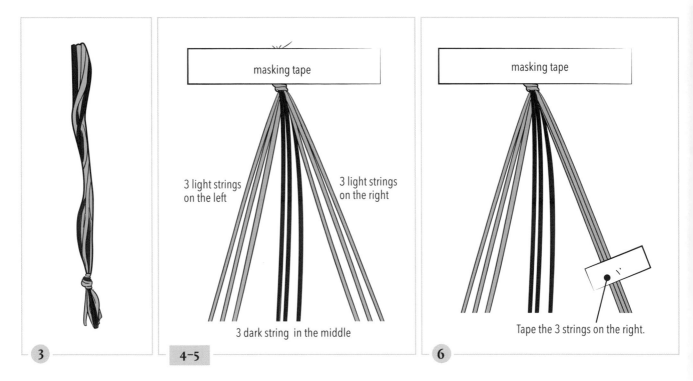

3. Gather all the strings together so the ends meet at the top. Tie a single overhand knot with all the strings about 5 inches down from the top.

4. Tape the knot to a flat surface.

5. Separate the strings so there's 3 light strings on the right, 3 dark strings in the center, and 3 light strings on the left.

6. Tape down the 3 strings on the right to get them out of the way. You won't need them for now.

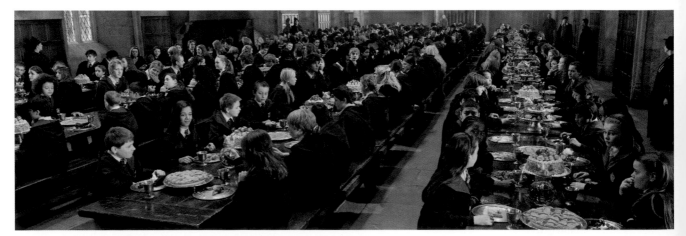

ABOVE: In the Great Hall, Hogwarts house members contemplate rows of pies and puddings set out for dessert in *Harry Potter and the Order of the Phoenix*.

There are two basic knots that you'll be using to create this bracelet: a forward knot (**step 7**) and a backward knot (**step 13**). Forward knots are used when you're working from the left toward the center. Backward knots are used when working from the right into the center.

MAKING A FORWARD DOUBLE KNOT

7. Start with the string that's third in from the left. We'll call this your knotting string. Arrange your knotting string in the shape of a 4 over the string to its right (A). Then take the end of the knotting string and loop it around the back of the right string and through the hole of the 4 (B). While holding the right string taut, pull the knotting string all the way up to the top of the right string (C). Repeat to make a double knot (D).

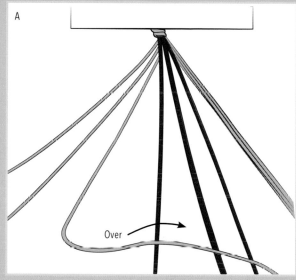

A. Make the shape of a 4, placing the left string over the top of the right string.

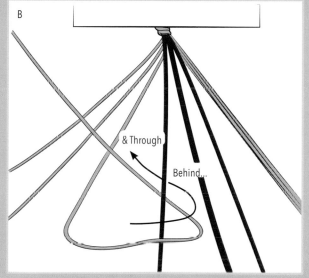

B. Weave the tail end of the left string behind the right string and through the hole of the 4 shape.

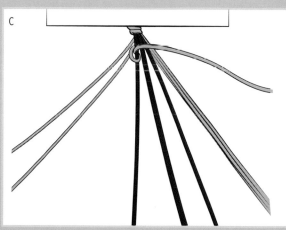

C. Pull the left string all the way up to the top until it can't go any farther,

D. Repeat A through C to make the second knot.

Close up of first knot:

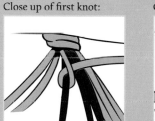

Close up of second knot:

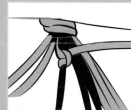

TIP: Tie your knots fairly loose. It makes for a nicer-looking bracelet and makes it easy to pull the knots out if you make a mistake. If you do need to untie any knots, gently poke a toothpick into the center of the knot and pull it open.

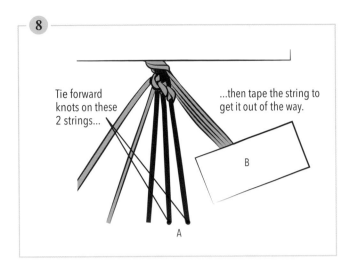

Tie forward knots on these 2 strings...

...then tape the string to get it out of the way.

B

A

8. Using the same knotting string from step 7, tie forward knots onto each of the next 2 center strings (A). When you're done, put the knotting string under the tape with the rest of the strings to get it out of the way (B). You've completed your first row!

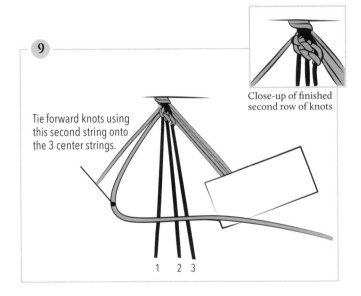

Close-up of finished second row of knots

Tie forward knots using this second string onto the 3 center strings.

1 2 3

9. For the second row, take the second string in from the left and tie forward knots onto each of the 3 center strands. When you're done, put it under the tape to get it out of the way.

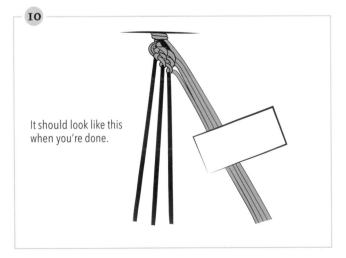

It should look like this when you're done.

10. For the third row, take the remaining string on the far left and tie forward knots onto the 3 center strands.

PREPARING YOUR BRACELET FOR WORKING THE RIGHT-SIDE ROWS

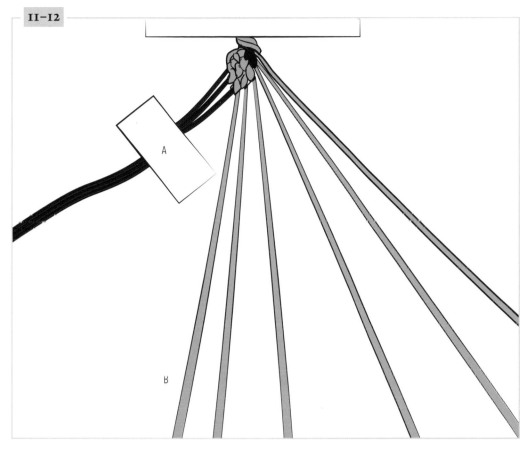

11. Pull the 3 leftmost strings off to the side and tape them down to get them out of your way (A).

12. Untape the 6 strings on the right and separate the strings as shown in (B).

"NOW, WHILE YOU ARE HERE, YOUR HOUSE WILL BE LIKE YOUR FAMILY."

Professor McGonagall, *Harry Potter and the Sorcerer's Stone*

BEHIND THE MAGIC

Costume designer Jany Temime lined the students' robes with their house colors, wanting to ensure that each student's house could be seen clearly at all times, even across the Great Hall.

MAKING A BACKWARD DOUBLE KNOT

13. Start with the light-colored string that's third in from the right. Arrange it in the shape of a backward 4 over the string to its left (A). Take the end of the knotting string and loop it around the back of the left string and through the hole of the shape (B). Pull the end all the way up to the top (C). Repeat to make a double knot (D).

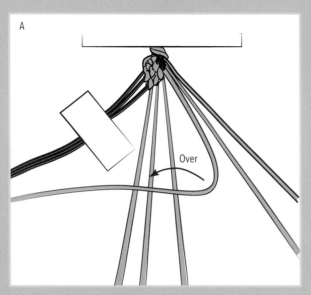

A. Make the shape of a backward 4, placing the right string over the top of the left string.

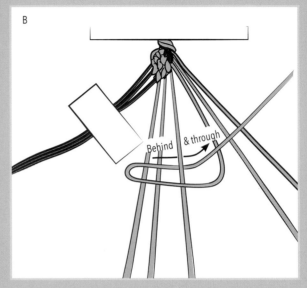

B. Weave the tail end of the right string behind the left string and through the hole of the 4 shape.

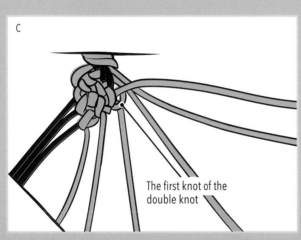

C. Pull the right string all the way up to the top of the left string.

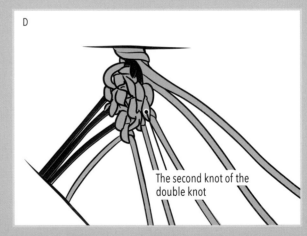

D. Repeat the backward knot on the same string.

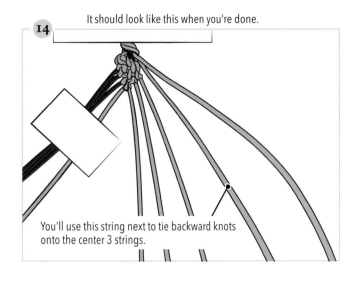

14 It should look like this when you're done.

You'll use this string next to tie backward knots onto the center 3 strings.

14. Using the same knotting string from step 13, tie **backward knots** onto each of the remaining 2 strings in the middle. When you're done, place the knotting string under the tape to get it out of the way.

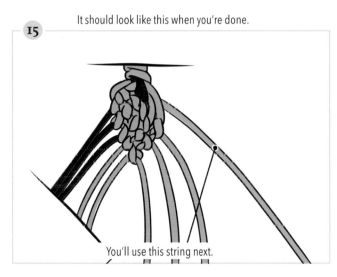

15 It should look like this when you're done.

You'll use this string next.

15. Now take the second string in from the right and tie **backward knots** onto the 3 middle strings. When you're done, place the string under the tape to get it out of the way.

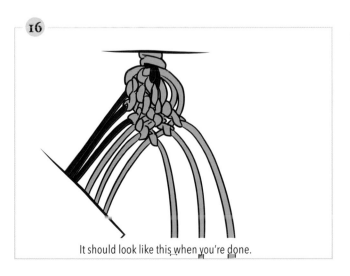

16

It should look like this when you're done.

16. Take the last string on the right and tie **backward knots** onto the 3 middle strings.

17. Untape the string bunch on the left and separate the strings (A).

Tape the 3 strings on the right to get them out of your way (B).

18. Tie forward knots with the 3 strings on the left onto the 3 strings in the middle (A, B, C).

19. Tie backward knots with the 3 strings on the right onto the 3 strings in the middle (A, B, C).

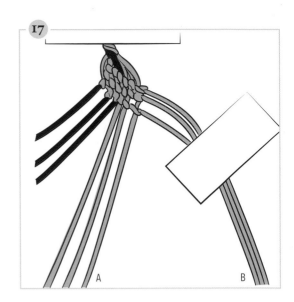

17

A B

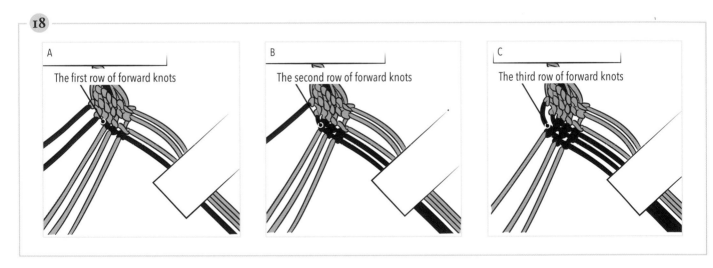

18

A
The first row of forward knots

B
The second row of forward knots

C
The third row of forward knots

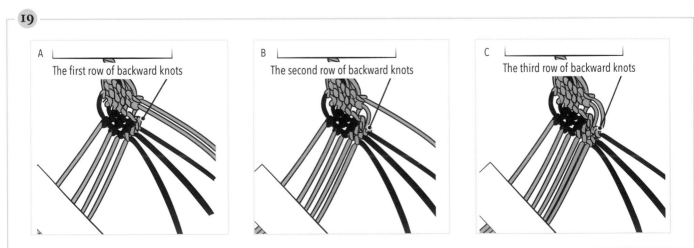

19

A
The first row of backward knots

B
The second row of backward knots

C
The third row of backward knots

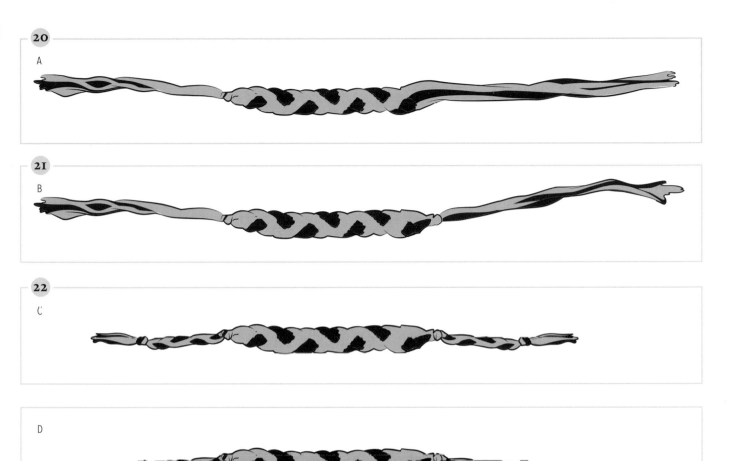

20

A

21

B

22

C

D

20. Continue tying forward knots with the 3 left strings onto the middle 3 strings and then backward knots with the right 3 strings onto the middle 3 strings until your bracelet is about 5 to 6 inches long or until it fits nicely around your wrist (A).

21. Remove the tape from your bracelet and tie a single overhand knot with all the strings at the bottom (B).

FINISHING THE ENDS

22. Braid both ends of the bracelet by creating three bunches of strings (3 light strings, 3 dark strings, and 3 light strings) on each side. The right bunch goes over the center and becomes the new center. Then the left bunch goes over that center bunch, then the right bunch goes over that center bunch. Continue braiding like this until you get to the end. Tie all the strands in a tight knot to secure the end (C) and trim the excess strands close to the knot (D).

> **TIP:** If you're having trouble, tape the bracelet down to a flat surface to hold it steady so you can pull the strands taut while braiding.

23. Have a Hogwarts friend tie your bracelet on your wrist.

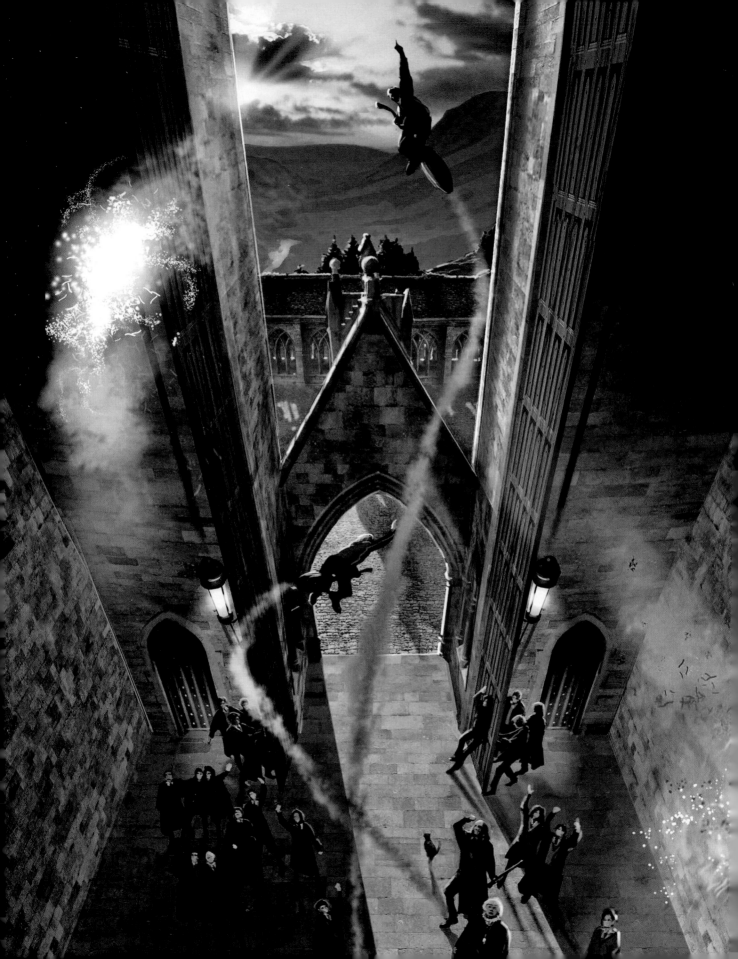

CHAPTER 2:
IN THE CLASSROOM

"THERE WILL BE NO FOOLISH WAND-WAVING OR SILLY INCANTATIONS IN THIS CLASS."

Severus Snape, *Harry Potter and the Sorcerer's Stone*

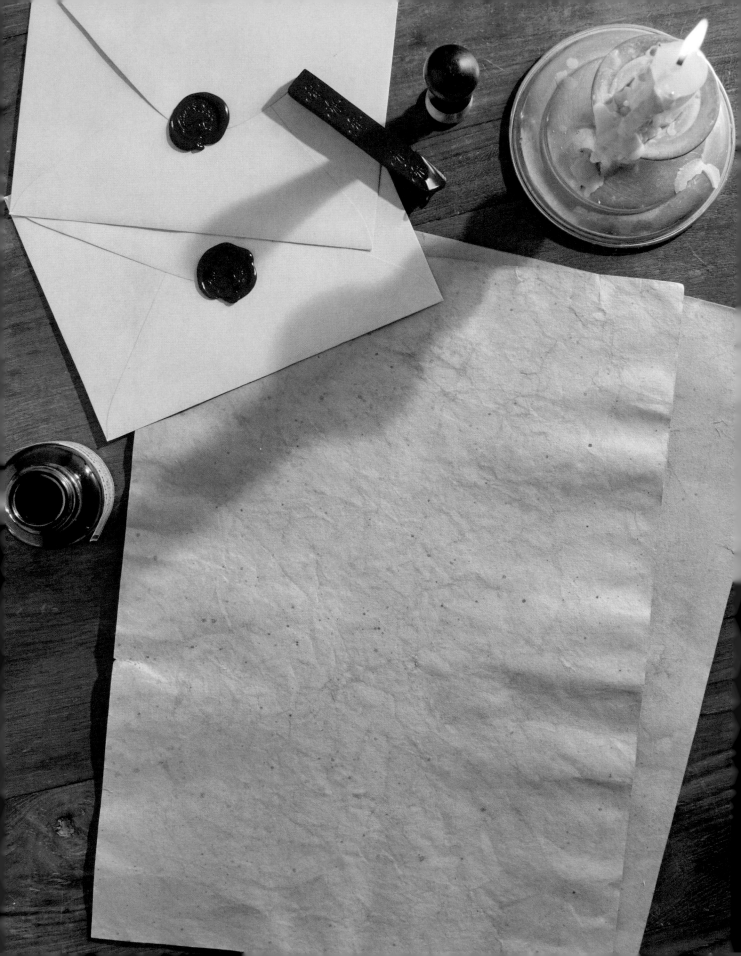

PARCHMENT

Designed by **JILL TURNEY**

SKILL LEVEL ⚡

Parchment is the most prevalent writing material in the wizarding world, used for documents as large as the Marauder's Map, a magical map that displays the location of every person and ghost in Hogwarts, and as small as the pieces dropped into the Goblet of Fire's flames in hopes of becoming a Triwizard Tournament champion. Parchment dates back to the second century BC and was used for illuminated manuscripts in the Middle Ages, written with silver and gold inks. Hogwarts students write on parchment for their homework assignments, using a sharp quill pen dipped in ink—in *Harry Potter and the Prisoner of Azkaban*, Professor Snape asks for two entire rolls of parchment on the subject of werewolves. When Hermione Granger founds an organization of students committed to learning defensive magic in *Harry Potter and the Order of the Phoenix*, she has them all sign a piece of parchment as members of Dumbledore's Army. Making your own parchment requires only a few materials, many of them from your own kitchen. Using a variety of tea types, including herbal teas, will create different shades of parchment color, and all will smell delightful.

WHAT YOU NEED:

- Sheet of yellow construction paper (or more if you want to make more parchment paper)

- Baking sheet with sides (or a large baking dish)

- ¾ cup boiling water

- Measuring cup

- 2 black tea bags

- Paper towels

- Masking tape

OPTIONAL:

- Brown watercolor paint

- Paintbrush

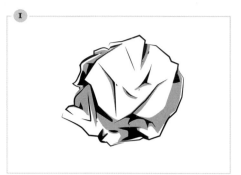

1. Crumple the sheet of paper

2. Gently uncrumple the paper (making sure not to rip it), and lay it flat on the baking sheet.

3. Set water to boil.

4. Carefully pour ¾ cup of boiling water into a measuring cup.

5. Put 2 black tea bags in the measured boiling water. Leave them alone for 5 minutes as they steep.

6. Pour the steeped tea over the paper. Turn the paper over, and let the tea soak in just a bit.

7. Pour the excess tea out of the baking sheet.

8. Dab a tea bag over random areas of the paper to make darker splotches. Let sit for a few minutes to soak.

9. Lay a few paper towels over the paper to soak up some of the moisture.

10. Turn the paper over, and repeat steps 8 and 9.

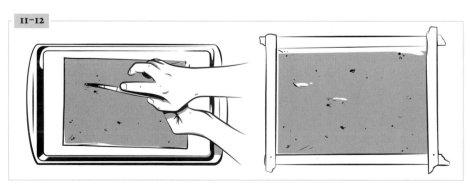

11. Optional: If you want to add some spotting detail to your parchment texture, load a paintbrush with brown watercolor paint and tap it over the top of your tea-soaked paper. Turn the paper over, and repeat.

12. Lay the paper on a flat surface, and smooth it out to make it as wrinkle-free as possible. Tape down all 4 sides securely. Leave it to dry for at least 12 hours.

13. Once dry, carefully remove the tape. Now your parchment is ready for writing! Important! If your paper rips along the edge when removing the tape, simply trim that part off.

"...ON MY DESK BY MONDAY MORNING, TWO ROLLS OF PARCHMENT ON THE WEREWOLF WITH PARTICULAR EMPHASIS ON RECOGNIZING IT."

Professor Snape, *Harry Potter and the Prisoner of Azkaban*

Behind the Magic

In *Harry Potter and the Half-Blood Prince*, Hermione lists parchment as one of the aromas she smells in the Amortentia love potion.

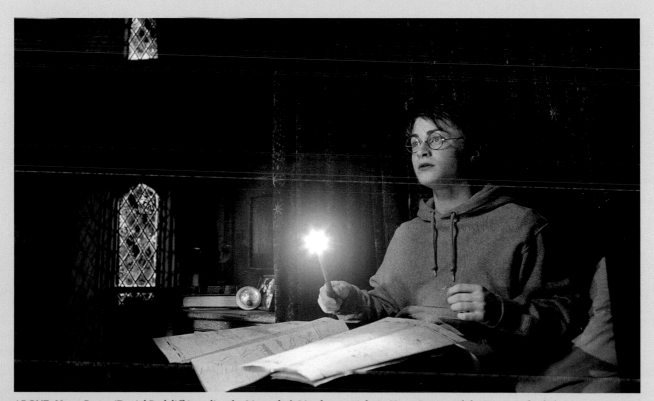

ABOVE: Harry Potter (Daniel Radcliffe) studies the Marauder's Map late at night in *Harry Potter and the Prisoner of Azkaban*.

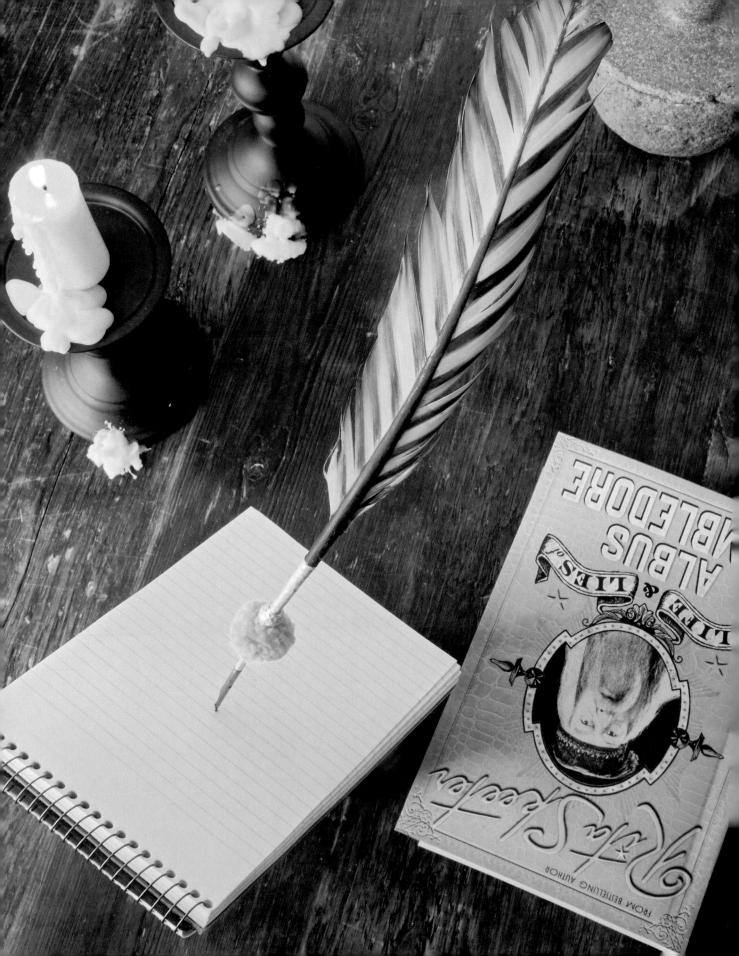

Rita Skeeter's Quick-Quotes Quill Pen

Designed by **JILL TURNEY**

SKILL LEVEL ⚡

Wizards typically write on parchment paper using ordinary feathered quill pens, which can be purchased at Scribbulus Writing Implements in Diagon Alley. There are, however, other pens in the wizarding world that have their own unique qualities.

In *Harry Potter and the Goblet of Fire*, Harry becomes one of four champions selected to compete in the Triwizard Tournament. This newsworthy event just begs for publicity, and so the *Daily Prophet* sends Rita Skeeter, a reporter with a flashy appearance and dubious reputation. When she interviews Harry, Rita uses a Quick-Quotes Quill, a feathered writing implement that changes his responses to her questions into something more sensational and frequently untrue. The pen's feather is dyed acid-green, a color that complements the outfit Rita wears during her cross-examination of the young student.

WHAT YOU NEED:

- Large white craft feather
- Green alcohol-based marker
- Black alcohol-based marker
- Scissors
- Bamboo skewer
- Ruler
- Pencil
- Utility knife
- Craft glue
- Gold paint
- Paintbrush
- Green craft pom-pom
- 2 wide-hole gold beads (or any wide-hole beads painted gold)
- Crow quill pen nib with tubular metal shaft

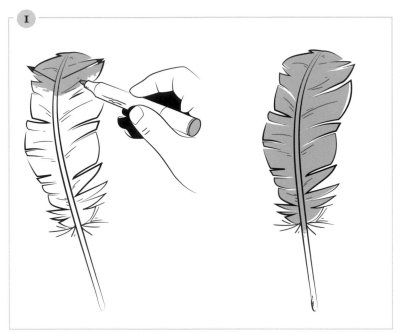

1. Color the top area of the feather with the green marker (both sides). This works best if you start with your pen at the shaft and drag it along the natural diagonal direction of the feather hairs. Leave the bottom of the shaft uncolored.

2. Once the green is dry, add diagonal black stripes every half inch down the right side of the feather. Repeat as a mirror image on the left side. Do the same on the back side.

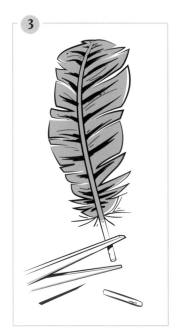

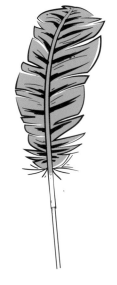

3. Cut off about 1 inch from the bottom of the feather's shaft. Try inserting the skewer into the bottom of the shaft. If it doesn't fit, trim off a little more of the shaft until it does fit.

4. Measure 4 inches up from the pointed end of the skewer and make a pencil mark.

5. With a utility knife, slice the skewer at the pencil mark. If it doesn't slice all the way through, just do a partial slit and break off the end with your hands.

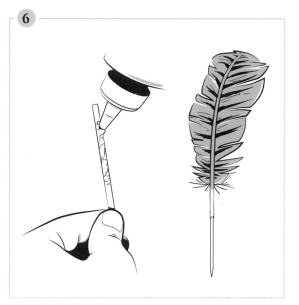

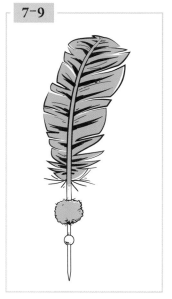

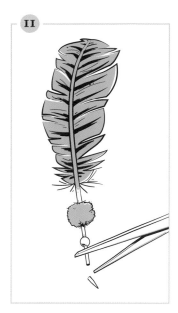

6. Apply glue to the top of the skewer, and insert it into the feather shaft. Allow to dry.

7. Paint the shaft and skewer gold, stopping at the bottom of the green feather area. Allow to dry.

8. Poke the pom-pom with the pointy end of the skewer, and slide it up the shaft.

9. Add some craft glue to the inside of a bead, and slide it up to rest at the bottom of the pom-pom.

10. Apply some glue to the inside of the second bead, and slide it up the shaft about a ½ inch below the first bead.

11. Snip off the pointy end of the skewer.

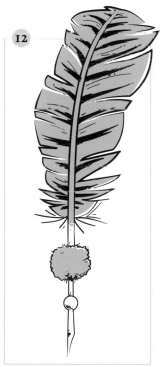

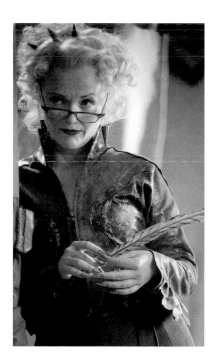

12. Apply a bit of glue to the end of the skewer, and slide the pen nib onto the end.

"DON'T MIND IF I USE A QUICK-QUOTES QUILL, DO YOU?"

Rita Skeeter,
Harry Potter and the Goblet of Fire

LEFT: Miranda Richardson as Rita Skeeter. Her imitation dragonskin jacket and spiky headband complement the dragon-based first task of the Triwizard Tournament.

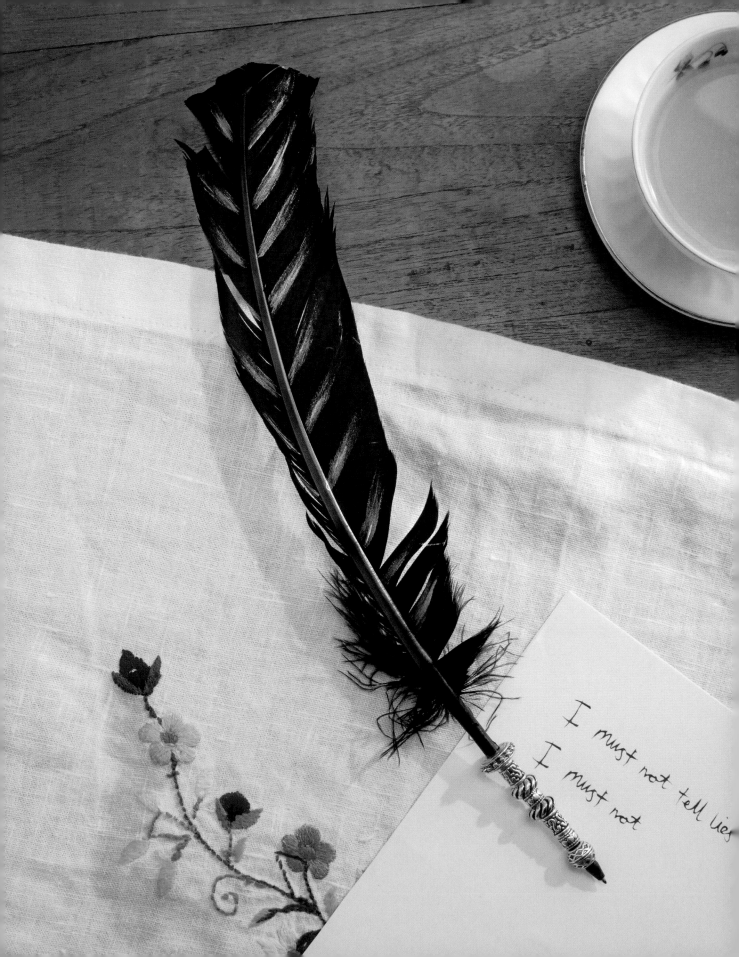

DOLORES UMBRIDGE'S BLACK QUILL

Designed by **JILL TURNEY**

SKILL LEVEL ⚡

I n *Harry Potter and the Order of the Phoenix*, Dolores Umbridge, the latest in a series of Defense Against the Dark Arts professors, finds a cruel way of punishing the members of Dumbledore's Army for breaking Educational Decree No. 68: "All student organizations are henceforth disbanded." Umbridge has them each write an assignment on parchment with a Black Quill, which is a Dark object with a Dark purpose. This quill doesn't need ink; instead, it writes with the blood of the person using it. Harry Potter already has served detention with Umbridge, during which he was forced to use a Black Quill to write "I Must Not Tell Lies" over and over, "as long as it takes for the message to sink in," she instructed him.

Unlike the Black Quill, this quill pen uses regular ink, but, with the help of some metallic beads, you can create a version that looks just like Umbridge's Dark artifact. Or, you can use the same technique to customize your own quill pen and make something cheerier!

WHAT YOU NEED:

- Large black craft feather
- Silver water-based paint
- Paintbrush
- Scissors
- Ballpoint pen
- Needle-nose pliers
- Assorted wide-hole ornamental metal beads
- Hot glue gun

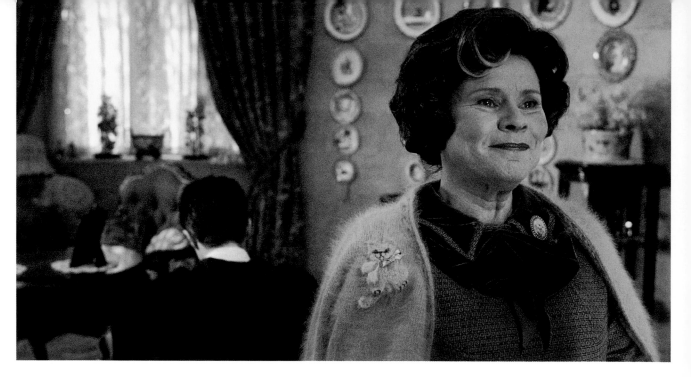

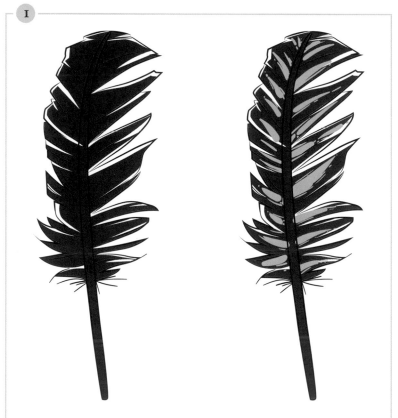

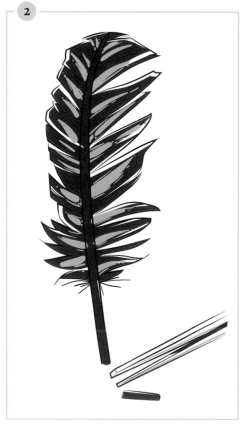

1. Paint diagonal wispy silver streaks along the left and right sides of the feather, starting from the inner shaft and brushing out to the outer hairs. If desired, repeat on the back side.

2. Cut off about a ½ inch from the bottom of the feather's shaft.

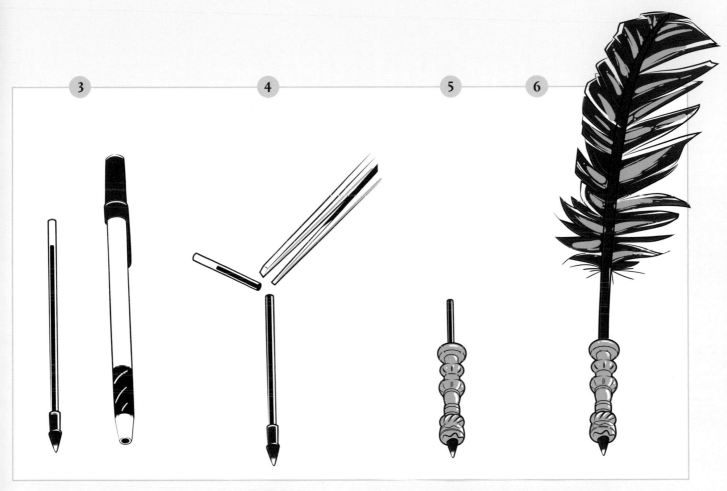

3. Remove the ballpoint pen barrel from its plastic shell with the pliers.

4. With scissors, trim off about 1½ inches of the top of the pen barrel. Be careful—this part can be a little messy if the ink drips out.

5. Thread metal beads onto the pen barrel until they measure about 2 inches tall.

6. Apply some hot glue to the top bead and the top of the pen barrel and insert the exposed pen barrel into the feather shaft. Do this quickly, before the glue hardens.

OPPOSITE TOP: Dolores Umbridge (Imelda Staunton) enjoys the detention she's assigned to Harry Potter (Daniel Radcliffe) as he writes "I Must Not Tell Lies" with her Black Quill pen.

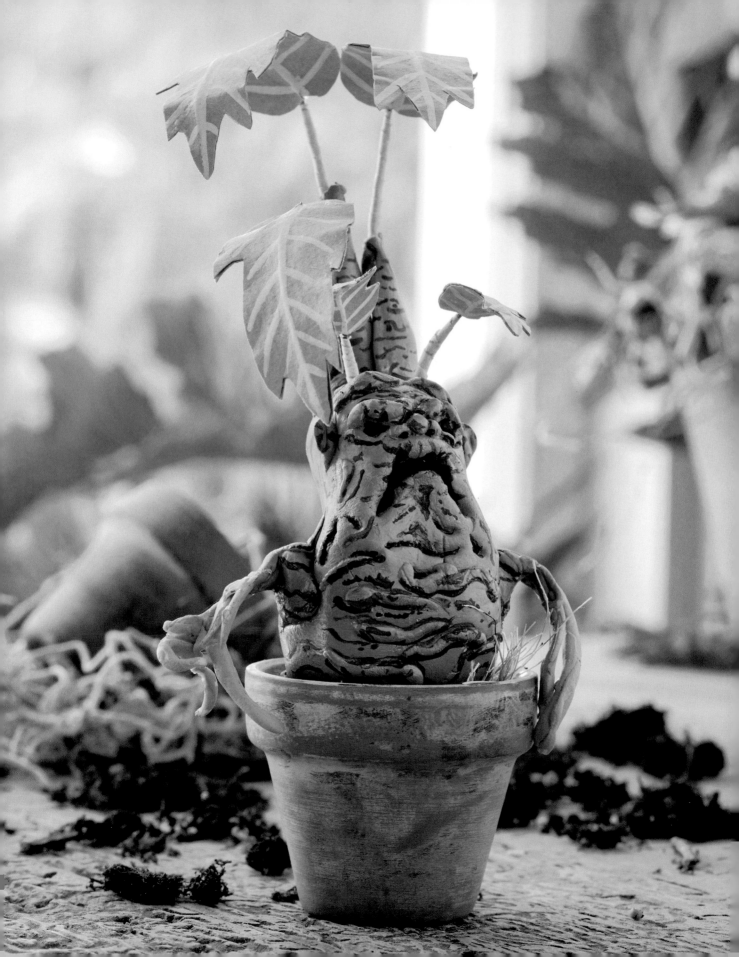

HERBOLOGY:
MINI POTTED MANDRAKE

Designed by **JILL TURNEY**

SKILL LEVEL ⚡⚡⚡

Herbology professor Pomona Sprout's introductory lesson for her second-year students in *Harry Potter and the Chamber of Secrets* is to repot Mandrakes, which are based on a real humanoid-looking root. Mandrake, also known as *mandragora*, is a key ingredient in the Mandrake Restorative Draught, an antidote to anyone who has been Petrified. Repotting Mandrakes can be hazardous, as hearing their cries can be fatal. These Mandrakes are still seedlings, so their cries won't kill, but as Neville Longbottom learns, they may still knock one out for a couple of hours with their screeches, so wearing earmuffs is encouraged for this activity.

More than fifty completely mechanical Mandrakes were created by the creature shop for *Harry Potter and the Chamber of Secrets*. Their movement was created by animatronic puppetry: Inside the flowerpots was machinery that would cause the top half of their bodies to squirm and wiggle. Radio controllers were positioned under the Herbology table and could speed up or slow down the plants' motions. Once Mandrakes mature, they are chopped up for the Petrification cure, so the designers didn't want the babies to be too cute. But who wouldn't love these adorable baby Mandrakes?

WHAT YOU NEED:

- White air-dry clay
- 1¾-inch-tall terra-cotta flowerpot
- Toothpick or carving tool
- Ruler
- Twine
- Scissors
- Stem wire
- Wire cutters
- Green paper
- Acrylic paint in assorted colors: lime green, white, tan, dark brown
- Fine and medium-sized paintbrushes
- Glue
- Green masking tape

OPTIONAL:

- Fine-grit sandpaper

1. Break off a piece of air-dry clay that will fit into your flowerpot, and roll it into a ball. Put the rest of the clay in an airtight bag or container to keep it from drying out.

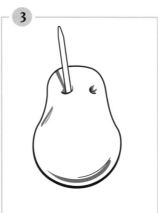

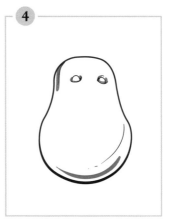

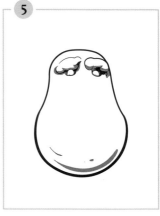

2. Form the clay ball into a pear shape.

3. Poke 2 eye sockets in the top part of the pear shape with a toothpick.

4. Roll 2 little balls of clay for eyeballs, and place them in the eye sockets.

5. Add small strands of clay above the eyes for eyebrows.

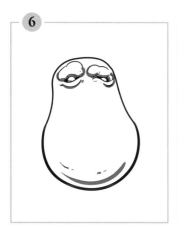

6. Add thin strands of clay under the eyes to form lower eyelids.

7. Centered below the eyes, carve a mouth shape. Pull the lower lip out slightly with your carving tool to give your Mandrake a disgruntled look.

8. Add a small round ball between the eyes for the nose. Add 2 small pieces of clay on either side of the nose for the nostrils. Poke holes with the toothpick for the nostril holes.

9. Add small pieces of clay on both sides of the head for ears, and add some bumps on the top of the head.

MAKING THE LEGS

1–2

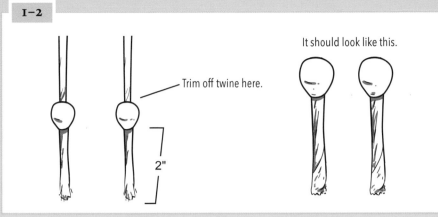

Trim off twine here.

It should look like this.

2"

1. Cut two 4-inch strands of twine. Break off a couple of small pieces of clay, and wrap them around the twin pieces 2 inches up from the bottom.

2. Trim off the twine at the top of the clay.

3

4

5

3. Add the legs to the bottom of the Mandrake's body.

4. Unravel the exposed twine, and crinkle it up to make the twine look like roots.

5. Place the Mandrake in the pot with the roots filling the pot.

MAKING THE ARMS

1

2

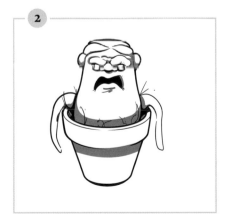

3

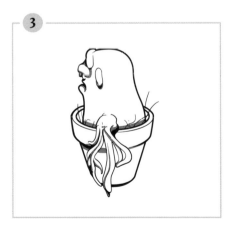

1. Break off two pieces of clay for the arms, and form each one in the shape of an apostrophe.

2. Add the round part of the apostrophe shapes to the body of the Mandrake at the flowerpot rim, and let the tail ends drape over the sides of the pot.

3. Roll some thin strands of clay, and stick random lengths of them to the arms to make fingerlike roots.

ADDING BRANCHES

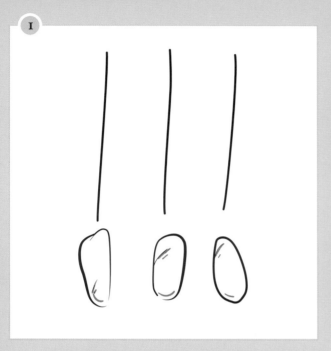

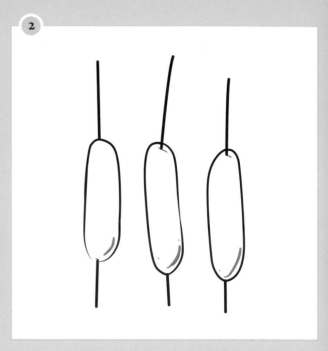

1. Cut three 4-inch pieces of stem wire, and break off 3 small wads of clay.

2. Wrap the clay around the wires like hot dogs on sticks.

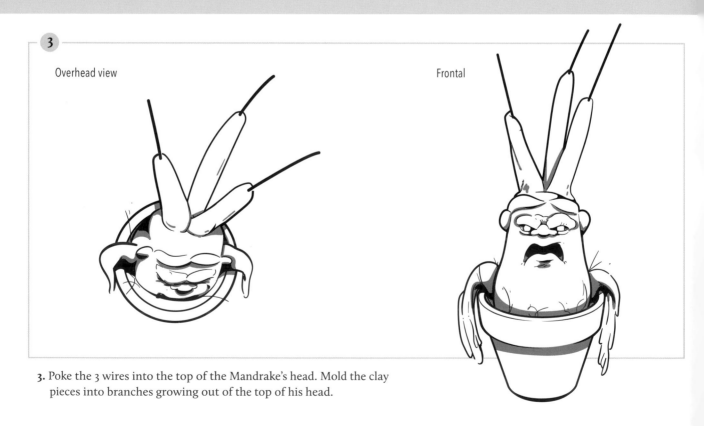

Overhead view

Frontal

3. Poke the 3 wires into the top of the Mandrake's head. Mold the clay pieces into branches growing out of the top of his head.

ADDING WOODY TEXTURE

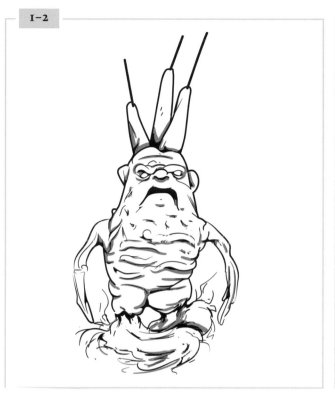

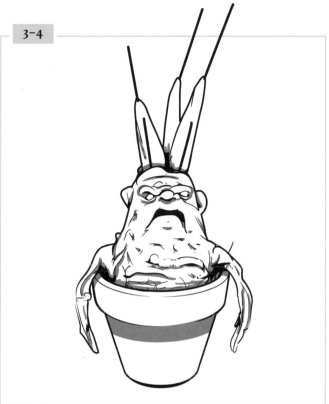

1. Take the Mandrake out of the pot. Make some strands and small balls of clay, and add them randomly over the body.

2. Using your toothpick or carving tool, make some woodgrain-looking lines in the clay.

3. Place the Mandrake back in the pot. Cut two 2 inch wires, and poke them in the Mandrake's head, in front of the head branches.

4. Place the Mandrake in a safe place for 12 hours to allow the clay to dry. When the clay is dry, carefully pull out the head wires.

Behind the Magic

Special Mandrakes were created for Professor Sprout and Draco Malfoy that could be removed from their flowerpots and continue moving—one was even able to bite Draco's finger!

MAKING LEAVES

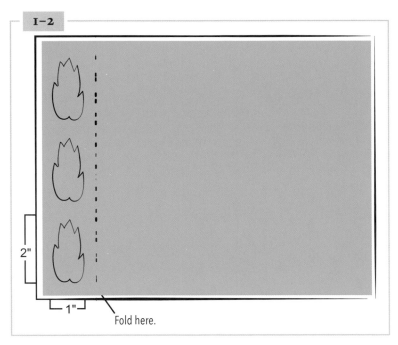

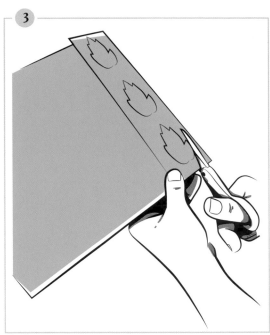

1. Draw 3 leaf shapes on the green paper, roughly 1-inch wide by 2-inches tall.

2. Fold the paper vertically so there are two layers to cut through to make your leaves. Important! The leaves should be showing on the outside of the fold.

3. Cut the leaf shapes out of the double layers of paper.

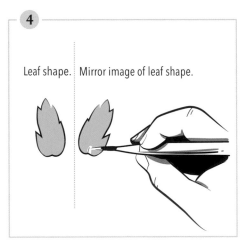

Leaf shape. Mirror image of leaf shape.

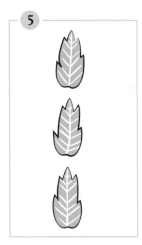

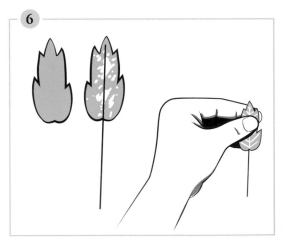

4. Lay the leaf shapes on a flat surface. Make sure each pair of leaves are mirror images of each other. Paint the center veins on each leaf with your thin brush and the lime green acrylic paint.

5. Paint thin strokes from the center vein to the outer edges of the leaves.

6. After the paint dries, flip the leaves over. Apply glue to one leaf of the set of mirrored leaves. Lay the 4-inch wire in the glue along the center of the leaf. Place the mirror leaf on top of the glued leaf and wire and press together until the glue dries. Repeat on the remaining 2 leaves.

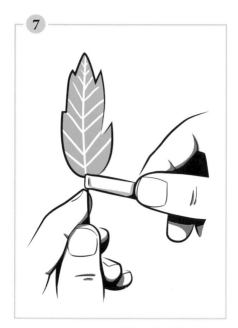

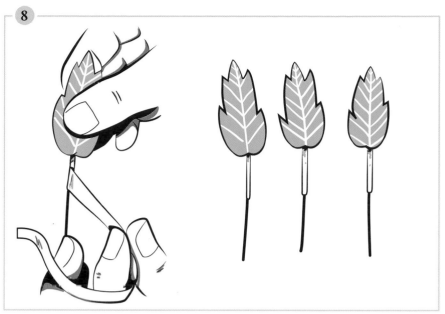

7. Rip about a 6-inch length of green masking tape from the roll. Cut a few ¼-inch strips from the tape piece.

8. Take one of the ¼-inch strips, and stick the end to the leaf wire right up against the bottom of the paper leaf. Wind the tape around the wire, overlapping it as you wind it down the length of the wire. Stop when your tape wraps half the wire. Rip off the excess tape. Repeat for the other 2 leaves.

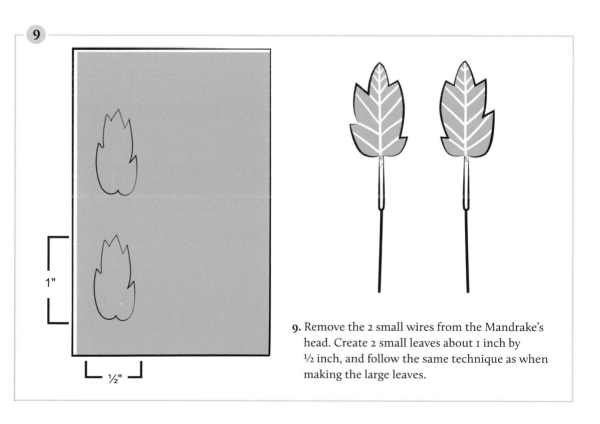

1"

½"

9. Remove the 2 small wires from the Mandrake's head. Create 2 small leaves about 1 inch by ½ inch, and follow the same technique as when making the large leaves.

PAINTING THE MANDRAKE

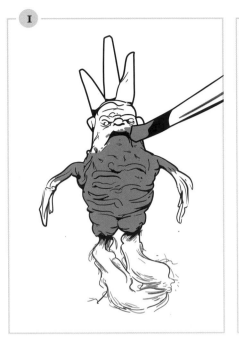

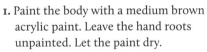

Tip: If the hand roots' clay strands stuck together while the Mandrake was drying, use a small pair of scissors to carefully cut the roots apart before painting.

1. Paint the body with a medium brown acrylic paint. Leave the hand roots unpainted. Let the paint dry.

2. Mix some white acrylic paint with the medium brown to make a lighter color for the hand roots (close to the shade of the twine roots). Paint the hand roots with the lighter color. Let the paint dry.

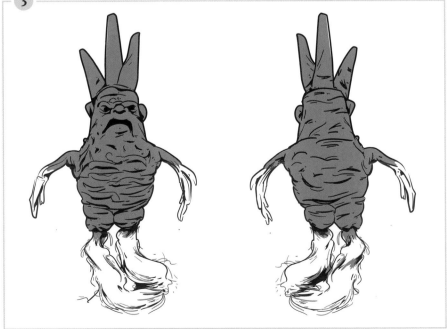

3. Paint the eye sockets, the nostrils, and the interior of the mouth with dark brown acrylic paint. Add shadows and thin-line woody details all around the body in the same dark brown.

OPTIONAL: PAINTING THE POT

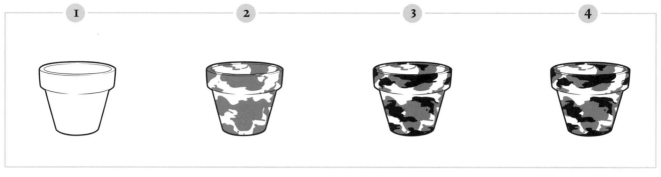

1. Paint the pot with your light brown acrylic paint.

2. Add some splotches of medium brown paint.

3. Add some splotches of dark brown paint.

4. Sand the pot using a fine-grit sandpaper, then rinse with water and allow to dry.

FINAL ASSEMBLY

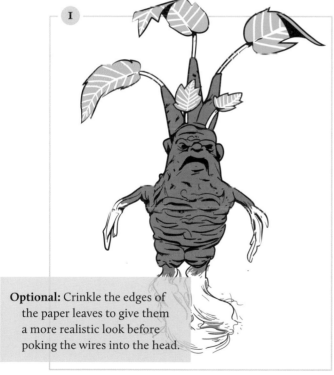

Optional: Crinkle the edges of the paper leaves to give them a more realistic look before poking the wires into the head.

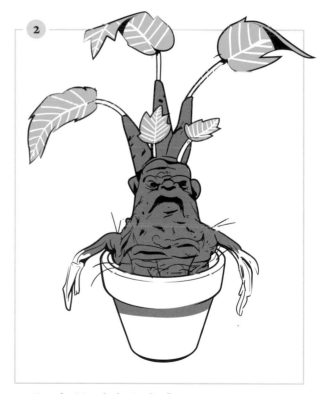

1. Poke the leaf wires back into the holes on top of the Mandrake's head. Bend the wires so the leaves flop down.

2. Put the Mandrake in the flowerpot.

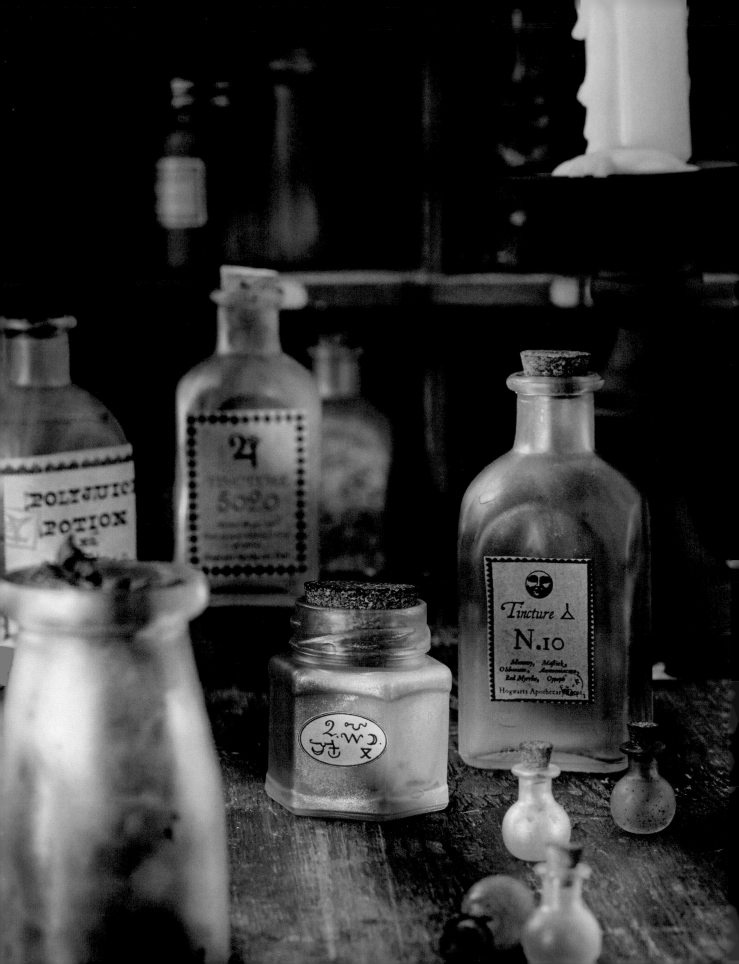

POTIONS:
POTIONS BOTTLES

Designed by **JILL TURNEY**

SKILL LEVEL ⚡

Potions class teaches the art of combining precise amounts of ingredients to produce magical elixirs, brews, and tinctures for myriad purposes: Hermione Granger brews Polyjuice Potion in *Harry Potter and the Chamber of Secrets* so that Harry and Ron can assume the appearance of Crabbe and Goyle (who are put out of commission by a Sleeping Draught) in order to infiltrate the Slytherin dormitory. In *Harry Potter and the Goblet of Fire*, the underage Fred and George Weasley drink an Ageing Potion in an attempt to enter the Triwizard Tournament. There are love potions, healing potions, and even cleaning potions. These and other concoctions are stored in bottles.

The Potions Master for the first five Harry Potter films is Severus Snape, whose classroom holds shelves filled with five hundred bottles, jars, and vials, ranging in size from several inches to several feet. Each bottle bears a label with ingredients, warnings, and serial numbers, all handwritten by the graphics department. When Horace Slughorn takes over the position in *Harry Potter and the Half-Blood Prince*, the number of potions bottles doubled to a thousand. You may not have room in your own potions cupboard for that many bottles, but with the endless varieties that can be created, you may not want to stop!

WHAT YOU NEED:

- Assorted clear glass bottles with cork tops, or household clear glass containers (soda bottle, mason jar, spice jar, etc.)

- Measuring spoons

- Paint-mixing pots

- Washable school glue

- Paintbrushes

- Acrylic paint in assorted colors: dark brown, metallic green, pearlescent blue

- Stamp pads of brown and silver, or any other color

- Stamping dabbers or makeup sponges

- Old toothbrush

- Fine-grit sandpaper

OPTIONAL

- Wide-mouthed container filled with marbles, rice, dried beans, sand, or similar items for weight

- Skewers or pencils

1. Remove the corks or lids and clean the outside of the jars or bottles.

2. Optional: Prepare a drying place for the bottles—fill a wide-mouth container with rice, beans, sand, or marbles. Poke pencils or skewers into the container so they're freestanding. Place a paper towel under the container to catch any drips.

3. Measure 1 tablespoon of water, and pour it in the paint pot.

4. Measure 1½ teaspoons of glue, and add it to the paint pot.

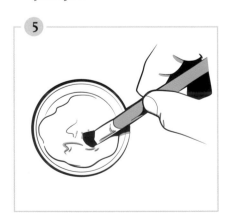

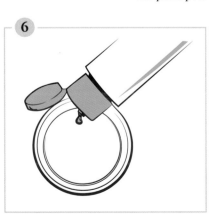

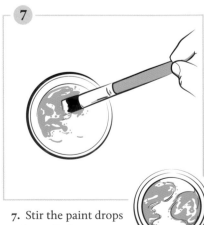

5. Mix the water and glue together thoroughly with a paintbrush.

6. Squeeze 2 drops of acrylic paint into the water and glue mixture.

7. Stir the paint drops just a little so you can still see the glue in the mixture.

8

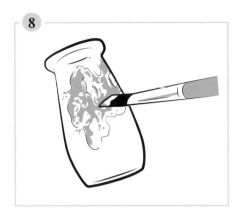

8. Dip your paintbrush in the mixture and then coat the outside of your glass bottle by dabbing the brush all over. Allow the mixture to pool up in some areas and flow thinly in others.

9

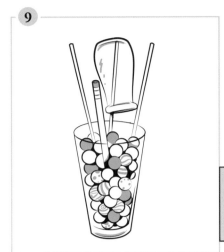

9. Prop the bottle upside down on one of the sticks in your drying container. You can continue to dab your paintbrush over the bottle as it sits on the stick. When you're happy with it, leave it alone to dry. Put the lid on your paint pot to save the mixture until you're ready to use it again.

TIP: For smaller bottles, place them upside down on the drying stick first, then paint them.

10

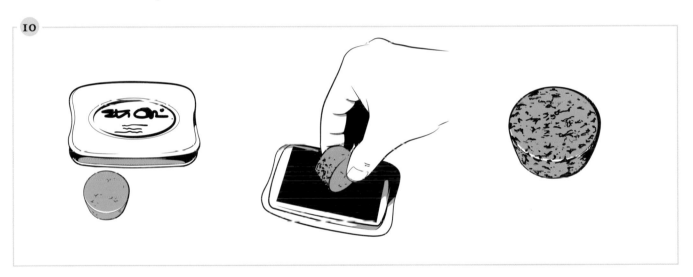

10. Grab your brown ink pad and the bottle's cork. Open the ink pad and roll the cork around on the pad so it picks up ink. Do this on all sides of the cork to give it a weathered look. Set aside to dry.

11. When the bottle and cork are dry, put them back together. Finally, add a potions sticker label (included in the back of this book), or create your own!

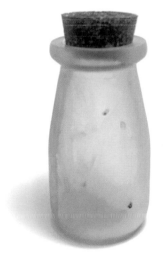

ADDING TEXTURE

A variety of techniques can give your potions bottles texture. Here are a few for you to try:

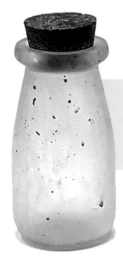

Speckles: Wet an old toothbrush and add a couple of drops of acrylic paint to the bristles. Rub your thumb across the bristles to spatter flecks of paint onto the bottle.

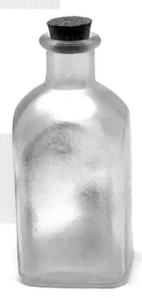

Rubber Stamping: Add some silver or other colors to your bottle with an ink pad and ink dabber.

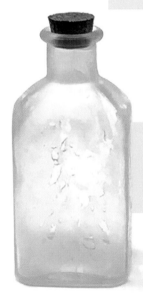

Sanding: Sand some of the glue mixture off your bottle with fine-grit sandpaper.

You can try this aging technique on a variety of clear glass items around the house such as soda bottles, food jars, and spice jars. Just make sure they're thoroughly clean. Try using a wine cork for the soda bottle. For jar lids, try painting them with metallic acrylic paint, and add a distressed look with some silver stamp pad ink.

Behind the Magic

Jars and bottles of potion ingredients seen on set in the Harry Potter films contained ginger root, dried herbs, rubber lizard tails, and tiny plastic animals.

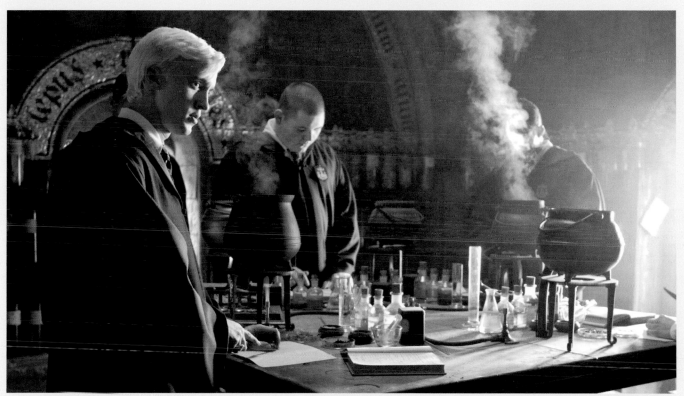

ABOVE: Draco Malfoy (Tom Felton) and his Slytherin classmates brew the complex Draught of Living Death as assigned by Professor Horace Slughorn in *Harry Potter and the Half-Blood Prince*.

"...FOR THOSE SELECT FEW WHO POSSESS THE PREDISPOSITION, I CAN TEACH YOU HOW TO BEWITCH THE MIND AND ENSNARE THE SENSES, I CAN TELL YOU HOW TO BOTTLE FAME, BREW GLORY, AND EVEN PUT A STOPPER IN DEATH."

Professor Snape, *Harry Potter and the Sorcerer's Stone*

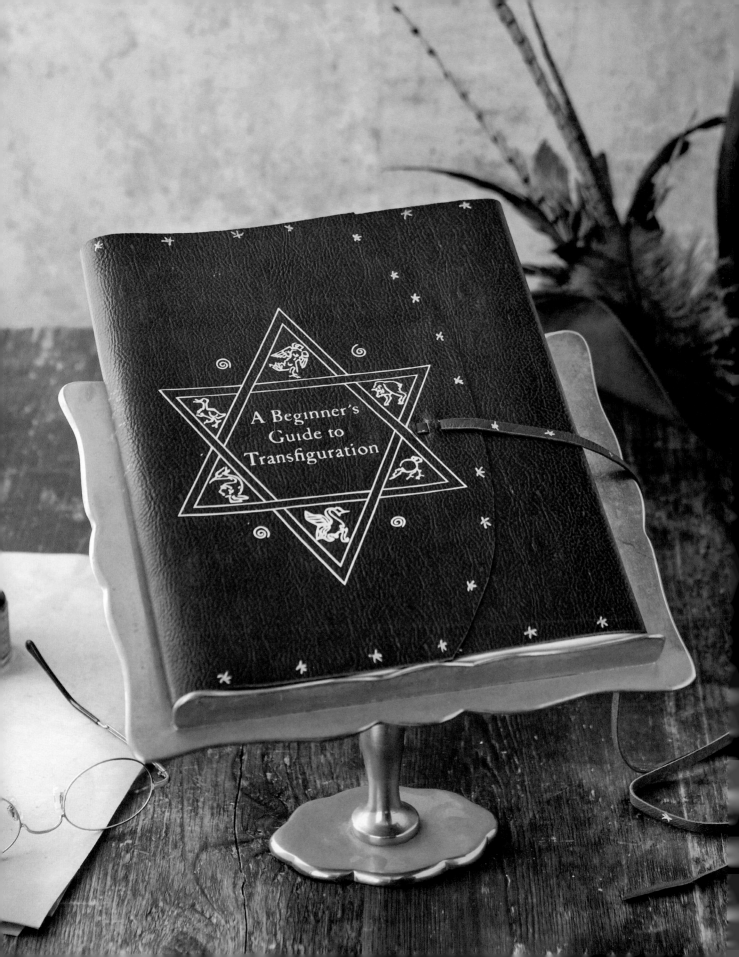

Transfiguration:
A Beginner's Guide to Transfiguration Textbook

Designed by **HEATHER VAN DOORN**

SKILL LEVEL ⚡⚡

Transfiguration, simply put, is the ability to transform one thing into another thing: a hornbill bird into a water goblet, a boy into a ferret, and even a man into an armchair (as Professor Slughorn can attest). Advanced study can teach a witch or a wizard how to willingly transform into an animal, an ability known as being an Animagus.

In *Harry Potter and the Sorcerer's Stone*, Harry and Ron run late for their first Transfiguration class and burst into the room where the students are working quietly, watched over by a gray tabby cat sitting on the professor's desk. Beside the cat is a copy of the course textbook, *A Beginner's Guide to Transfiguration* by Emeric Switch; Harry and Ron have brought their own copies. Suddenly, the cat jumps off the desk and turns into Professor McGonagall, who is none too pleased about the pair's tardiness.

The graphic design department, headed by Miraphora Mina and Eduardo Lima, hand-crafted textbooks for each Harry Potter film, based on the course curriculums set out in J.K. Rowling's novels. Twenty-five to forty copies were required for every class, depending on the number of students. An additional five to eight duplicates were needed for any schoolbook used by a main character, in case of damage. You need only transfigure the listed materials into one magical textbook.

WHAT YOU NEED:
- Blank sketchbook (7¾ by 9¾ inches; ½ inch or less thick)
- Faux-leather fabric (23 by 9¾ inches)
- Pencil
- Ruler
- Scissors (preferably fabric scissors)
- Scrap paper or cardboard
- Multipurpose spray adhesive (such as 3M Super 77)
- Faux-leather cord (or lace, ³⁄₁₆ by 36 inches)
- Hot glue gun and glue stick
- Gold paint pen, extra fine
- Cutting machine
- Cutting machine mat
- Cutting machine adhesive foil (gold)
- Alcohol wipes
- Cutting machine basic tool set or tweezers and small scraper
- Clear contact paper or transfer tape
- Craft knife

If not using a cutting machine, you will need:
- Tracing film for leatherworking
- Sponge
- Stylus (any material works)

1. Lay the sketchbook open on the back of the faux leather and trace along the top and bottom with a pencil.

2. Trace along the left edge of the sketchbook and then add 6 inches to the right side. Connect the lines with a ruler to make a rectangle.

3. Cut out the fabric along the lines you've traced, but curve the left side by rounding the edges on either end, as shown.

4. Cover the 6-inch curved section with scrap paper or cardboard, and then spray the back side of the fabric with adhesive and set aside.

5. Spray the cover of the sketchbook with adhesive, and let dry.

6. Carefully line up the back side of the faux leather with the back cover of the sketchbook, and press together. Make sure the edges line up.

7. Spray the front cover of the sketchbook, covering up the 6-inch flap again. When dry, pull the rest of the faux leather over the front cover and press firmly, making sure you line up the edge of the sketchbook to the edge of the adhesive. You should still have that 6-inch curved flap free.

8. Download the cutting machine template at www.insighteditions.com/craftingwizardry and cut out the design using your machine, the gold adhesive foil, and the cutting mat. If you're not using a cutting machine, see the "Alternate Method" box.

9. Wipe the front of the 6-inch flap with an alcohol wipe to ensure all grease and oils are removed from the cover. This will make sure you get a tight bond with the adhesive foil.

10. Peel off the negative space in the design so only what you want to transfer remains. You can use the weeder from the basic tool set or tweezers.

11. Place clear contact paper or transfer tape over the design and carefully pull it off the backing paper.

12. Center the design on the front flap, and press down. Using the scraper tool, work from the center out and rub the design onto the faux leather. Carefully peel back the transfer or contact paper, paying close attention to any part of the design pulling up as you are transferring. If that happens, carefully take a craft knife and free it.

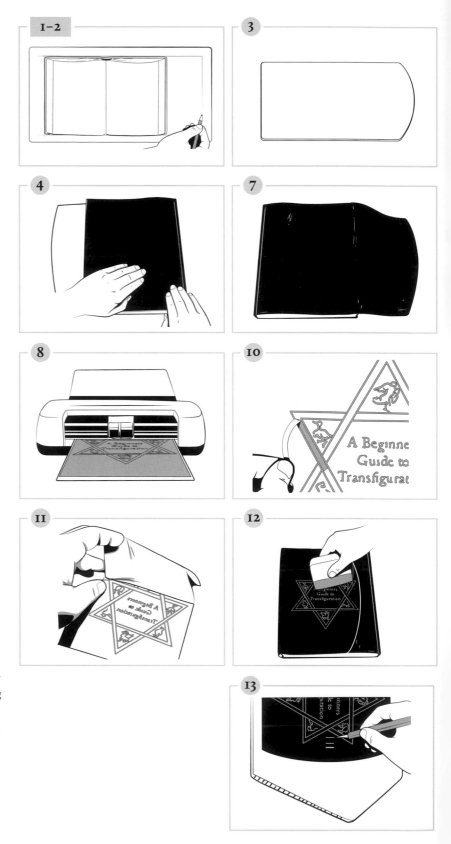

ALTERNATE METHOD

1. Trace the template included here using a pencil and tracing film.

2. Turn your traced image over, and trace that image, to make sure the art is the right way around when you place it. You can skip this step if you use transfer paper.

3. Use a sponge to wipe the front of the 6-inch flap on your textbook clean and dampen it a little. Avoid getting it too wet.

4. Place the tracing film face down (so it reads the correct way) and trace with a stylus onto the faux leather.

5. Use your gold paint pen to go over the lines left on the faux leather. Let dry, and continue with the regular step 13.

13. Turn the curved end of the flap toward you and a put a piece of cardboard under the flap.

14. Cut 3 small horizontal slits, each ¼ inch long. The first slit should be placed ⅝ inch from the edge, the second ⅞ inch from the edge, and the third 1³⁄₁₆ inches from the edge.

15. Insert the end of the faux-leather cording into the slit furthest from the edge. Flip the flap over and hot glue the underside into place.

16. Weave the rest of the cording through the next two slits and wrap the strap around the sketchbook and flap to hold flap in place.

17. Use the gold paint pen to draw stars around the edge and on the strap.

Template

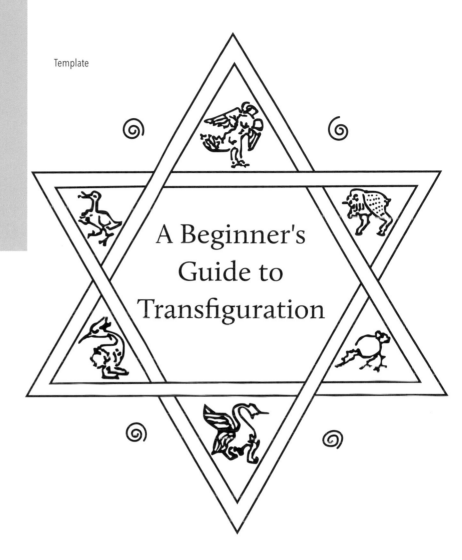

A Beginner's Guide to Transfiguration

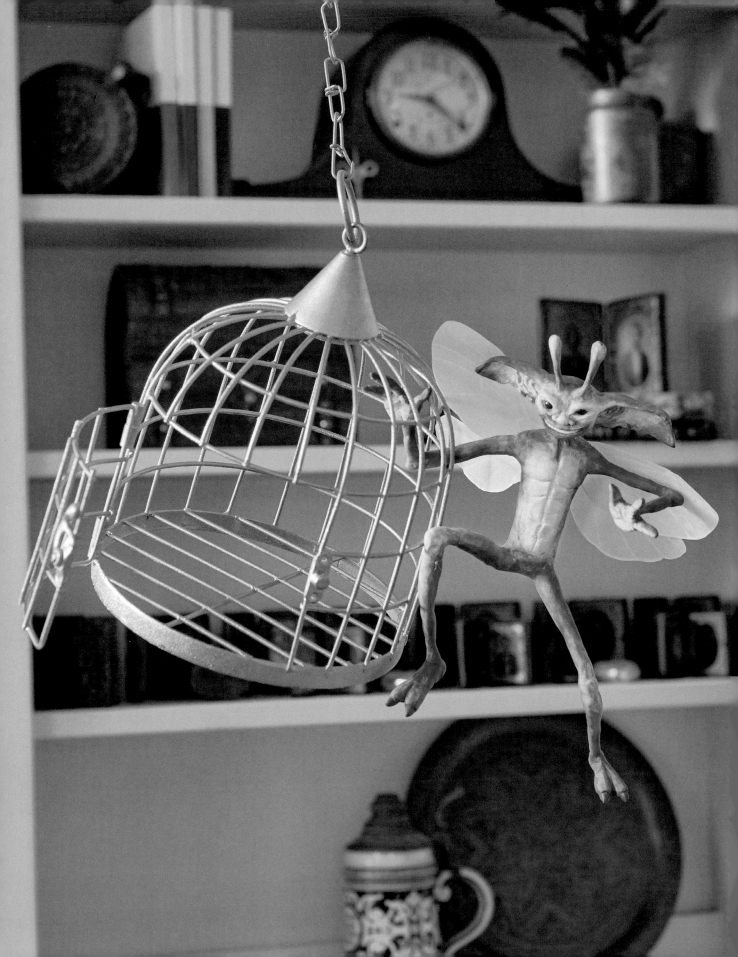

DEFENSE AGAINST THE DARK ARTS:
FROZEN CORNISH PIXIE

Designed by **HEATHER VAN DOORN**

SKILL LEVEL ⚡⚡⚡

When Gilderoy Lockhart takes over teaching Defense Against the Dark Arts in *Harry Potter and the Chamber of Secrets*, his reputation for tackling monsters such as trolls, vampires, and werewolves precedes him, as anyone can read about these in his published adventures. At his first lesson, Lockhart warns his students that they may be facing their worst fears in the room, but it is his job to arm them against the foulest creatures in wizardkind. This might seem a tad of an overstatement when he pulls the cover off a cage-rattling collection of small, electric-blue Cornish pixies. Once released, however, the pixies run amok in the classroom, knocking books off shelves and pulling the students' hair. A pair of pixies even flies Neville Longbottom up to the ceiling and suspends him from the hanging dragon skeleton. Lockhart bolts from the mayhem, and it's Hermione who halts their destruction with the Freezing Charm. *Immobulus!*

A scale-model Cornish pixie was created and painted by the creature shop, then cyber-scanned to animate more than twenty creatures that wreaked destruction throughout the classroom. The mess the pixies made was achieved by tugging thin wires attached to props, sending them falling or flying around the room. Keep your freshly made pixie immobilized to protect your room from its impish nature!

WHAT YOU NEED:

- Aluminum foil
- Scissors
- Mesh wire sheet
- Small straight pins with heads
- Two 2-ounce packs of blue oven-baked polymer clay
- Two 6mm black glass beads
- Armature wire
- Polymer clay tools
- Polymer clay softener
- Small paintbrushes
- Oven mitts
- Polymer clay glue
- Small eye screws
- Wing template (page 80)
- Vellum
- Small decorative cage
- Gold spray paint
- Hot glue gun and glue sticks
- White acrylic paint
- Makeup sponge
- Light pink acrylic paint
- Nylon string

MAKING THE HEAD

I

1. Make about a 1-inch ball of compressed aluminum foil.

2–3

2. Use scissors to cut 2 triangle shapes from the mesh wire sheet for the ears.

3. Attach the two ears to each side of the head using the straight pins.

4–5
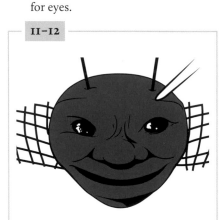

4. Apply a thin coat of blue clay over the aluminum ball.

5. Press 2 6mm beads into the head for eyes.

6–7

6. Cut two 1-inch lengths of armature wire and curve the ends a little.

7. Stick the uncurved ends of the wire into the head to make the pixie's antennae.

8–10
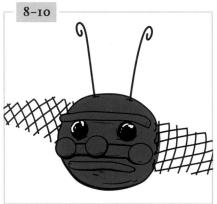

8. Roll out 3 thin snakes of clay.

9. Attach one snake along the brow line, another under the eyes, and one for the bottom lip.

10. Make 3 small balls for the nose and cheeks and attach those to the head.

11–12
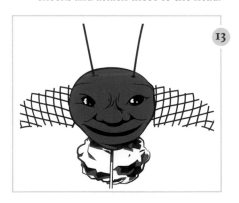

11. Using clay tools, blend the edges of the balls and snakes into the head and sculpt facial features.

12. When you have the head sculpted as you like, use the clay softener with a brush to get rid of any fingerprints.

13. Get ready to bake! You'll be baking the head twice so you don't have to worry about messing up any of your sculpting. Stick some armature wire to the bottom of the head to hold it up. Rest the head on a ball of foil on a baking sheet. This will make sure the head doesn't flatten while baking.

14. Bake according to the instructions on your clay's package.

15. Let cool.

MAKING THE EARS

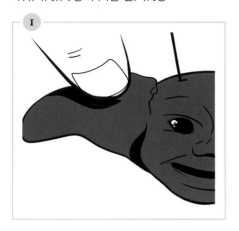

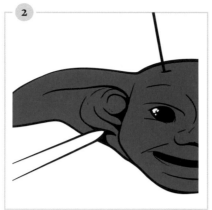

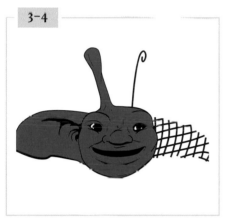

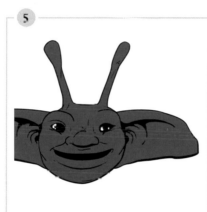

1. Now, start on the ears. Apply the polymer clay glue to one side of the head by the mesh wire. Cover the mesh wire with blue clay and secure the clay to the side of the head with the glue.

2. Roll out thin clay snakes for the ear. Attach the snakes along the edges of the ear to create the ear ridges. Attach even smaller snakes to the inside of the ear—3 small ones will give you the inner ear ridges.

3. Blend and sculpt the ear to your liking.

4. Cover the antenna closest to the ear you just made with blue clay and shape until you like how it looks.

5. Repeat steps 1 through 4 for the other ear and antenna. Then, use the clay softener again to remove any fingerprints.

6. Use the same setup as step 13 to bake the pixie's head again. Be careful to keep previously baked parts from touching the pan.

7. Let cool and set aside.

MAKING THE BODY

1. Make a compressed foil ball again, but this time, roll it so it looks like a rounded log. Check it against the head to make sure the sizing is right.

2. Twist two equal lengths of armature wire together and wrap the twist around the top quarter of your foil base. These will eventually be the pixie's arms.

3. Repeat step 2 around the bottom quarter of the foil base for legs.

4. Wrap the foil base in a layer of blue clay.

5. Roll balls of clay and attach them to the body for muscles along the front and back.

6. Use your clay tools to define the pixie's anatomy and sculpt it how you want to.

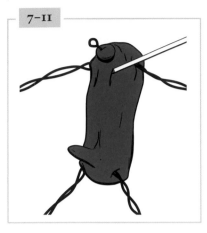

7–11

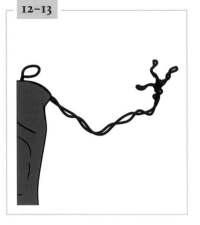

12–13

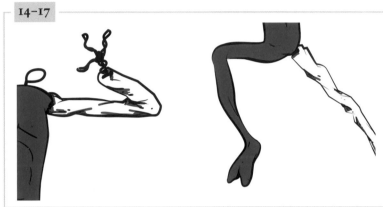

14–17

7. Insert a short piece of wire in back for the tail. Cover it with clay and shape.

8. If you're going to want to hang your pixie, insert an eye screw to the back now. (You can also make a loop out of wire and insert into the back.)

9. Make slits on the back for the wings to attach.

10. Use clay softener to remove fingerprints.

11. Bake, following the instructions on the clay package. Let cool.

12. Prop up the pixie, and bend the armature wires where you want the pixie's arms to be positioned.

13. Bend another length of wire for hands. Form 2 fingers and a thumb and leave one end of wire long for assembly. Attach by twisting the ends of the wires on the arms and hands together.

14. Wrap foil around the shoulders and forearms to bulk them up.

15. Wrap clay around the arms and hands and shape until you're happy with them. Apply clay glue to the body to secure the clay arms.

16. Bake and cool.

17. Repeat steps 12 through 16 for the legs, except instead of forming hands, form feet with two toes.

MAKING THE WINGS

1. Lay vellum over the wing image here and tape down the edge of the vellum so it doesn't slide around.

2. Use a stylus or clay tool to trace over the template for each set of wings, gently pressing against the lines. This will give the wings an embossed effect.

3. Remove tape, cut out the wings, and set aside.

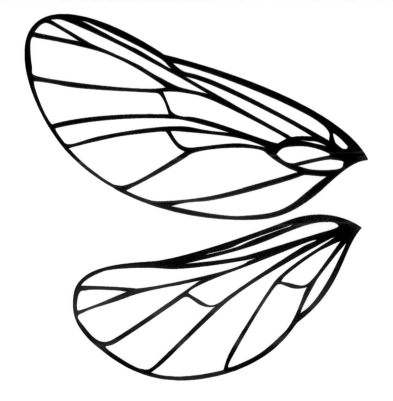

PAINTING AND ASSEMBLY

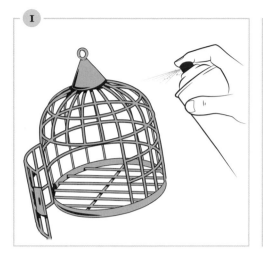

1. Spray-paint your cage gold and set aside to dry.

2. Hot glue the head and the body together.

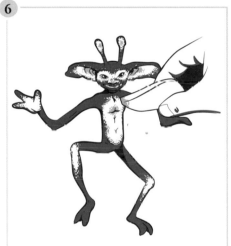

3. Thin the white paint with a bit of water. With a paintbrush, stipple the paint onto the body.

4. Using the makeup sponge, stipple a little more white paint, feathering and blending out to the sides of the paint area.

5. Build up paint layers slowly until you're happy with the results.

6. On the final layer, add a bit of light pink.

7. Attach wings into slots with a small dab of hot glue.

8. Position your pixie on the outside of the cage, and attach with hot glue and nylon string for added strength, or hang the pixie using wire loops or eye hooks from bottom of the cage.

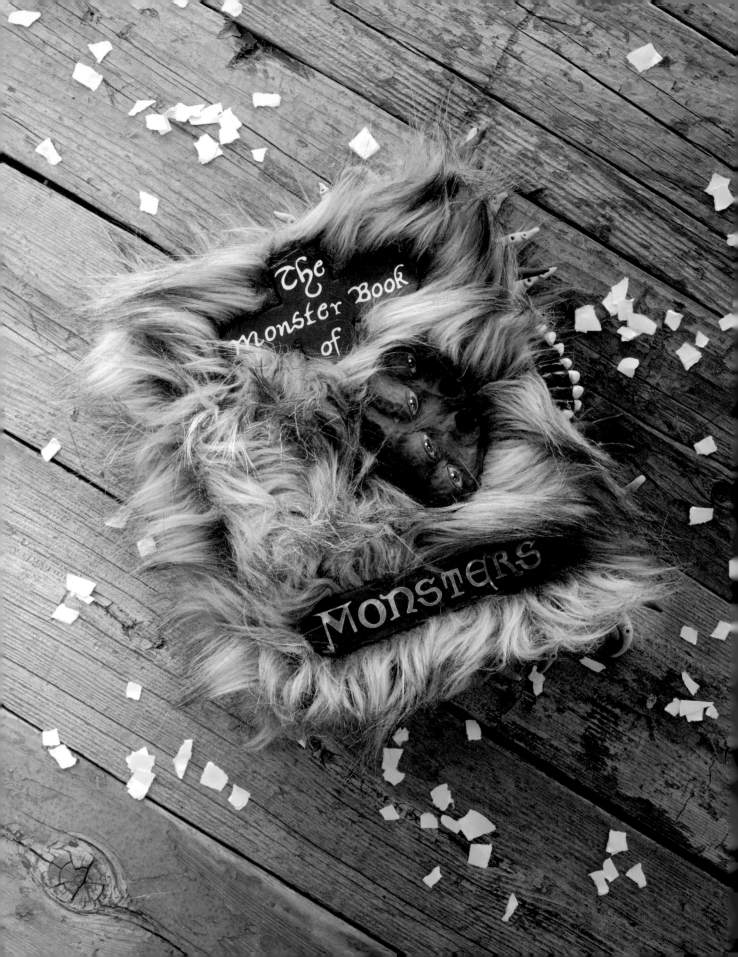

CARE OF MAGICAL CREATURES:
THE MONSTER BOOK OF MONSTERS

Designed by **HEATHER VAN DOORN**

SKILL LEVEL ⚡⚡⚡⚡

When Rubeus Hagrid becomes the Care of Magical Creatures professor in *Harry Potter and the Prisoner of Azkaban*, he assigns *The Monster Book of Monsters* to his students. This textbook could almost be one of the creatures he teaches about—when Harry Potter opens the book while staying at the Leaky Cauldron's inn, it immediately begins to snarl, bite, and even shred its pages as it charges at Harry. The only way he gets the book to stop attacking him is to jump on it to keep it shut. Finally, in his first class, Hagrid tells the students that they must stroke the book's spine in order to read the pages. Oh, of course!

Designer Miraphora Mina played with several concepts for the look of *The Monster Book of Monsters*—there was a version with clawed feet and a tail, and a version with literal spines on the spine of the book (a real challenge to stroke!). The final iteration had four eyes, lots of fake fur, tentacles, and teeth that kept the book shut. The book's red ribbon bookmark cleverly became its tongue. The "author" of the book, Edwardus Lima, is a play on the name of Mina's associate in the graphic design department, Eduardo Lima. You can fill your *Monster Book of Monsters* box with magical keepsakes; they'll be protected by its snarling jaws and menacing eyes.

WHAT YOU NEED:

- Unfinished wooden book box (9.75 by 7.5 by 2.88 inches)
- Acrylic paint in bright pink, dark brown, yellow-orange, terra-cotta, black, light gray, off-white, and ivory
- Paintbrushes (1 small, 1 medium)
- Ruler
- Needle tool
- Sandpaper
- Polymer clay in gray (two 2-ounce packages); medium brown (two 2-ounce packages); red (one 2-ounce package); tan (two 2-ounce packages); yellow (one 2-ounce package); and white (one 2-ounce package)
- Baking sheet
- Oven mitts
- Clay sculpting tools
- Armature wire
- Mesh wire sheet
- Wire cutters (or nail clippers)
- Gloss medium
- E6000 glue
- Matte decoupage glue
- Cutting machine
- Cutting machine template download
- Cutting machine mat
- Cutting machine adhesive foil (gold)
- Cutting machine basic tool set
- Contact paper or transfer sheet
- Fabric scissors
- Faux fur
- Black permanent marker
- Painter's tape
- Multipurpose spray adhesive (such as 3M Super 77)
- Hot glue gun and glue sticks

If not using a cutting machine, you will need:

- Tracing paper
- Pencil
- Book title template (page 90)
- Gold paint pen

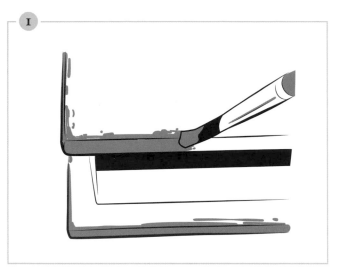

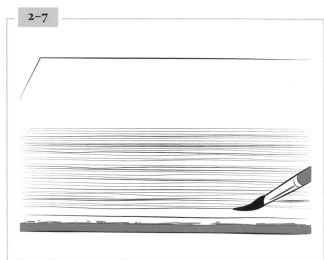

1. Paint the edges of your box dark brown

2. Paint the sides of your box (the "pages" of your Monster Book) off-white and ivory.

3. Use a ruler and a needle tool to score lines for "pages" across the sides of the box.

4. Use the needle tool to draw some more disorderly lines across the sides to rough it up and make it look like pages of an old book.

5. Use brown and yellow paint and a small paintbrush to paint over the grooves you just made.

6. Create a wash by mixing some dark brown and yellow paint with water. Brush it over the sides of the box to give the "pages" a worn look.

7. Just below the middle of one of the long sides of the box, carve out a small divot with tapered ends. It should be about 1 by ¼ inch around, and about a ¼ inch deep. You can use your needle tool for this. Set aside while you work on the other pieces.

MAKING THE FACE AND EYES

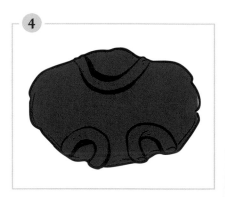

1. Mix equal amounts of gray and medium brown clay to get a gray-brown clay.

2. Flatten an oval disc out of the gray-brown clay for the face, approximately 4 by 2½ inches.

3. Roll a clay snake out of the mixed clay to form the top browline and set in place on the face disc. Mold into place

4. Roll two more smaller snakes and curve in place to make the nostrils. Mold them into place.

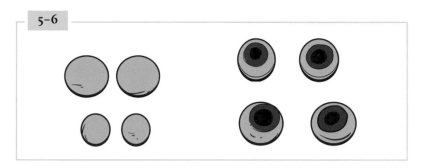

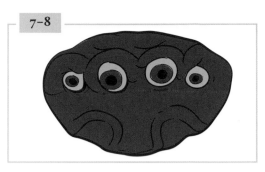

5. From the yellow clay, make 4 balls for the book's eyes—2 larger ones for the inner eyes, and 2 smaller for the outer ones.

6. On each yellow ball, paint a dark brown circle for the irises. Top that with a smaller black circle and let dry.

7. Place the two larger eyes in the center of the face, with the smaller eyes on either side.

8. Roll out 4 short, stubby snakes out of the gray-brown clay and curve one behind each yellow eye.

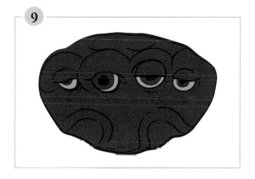

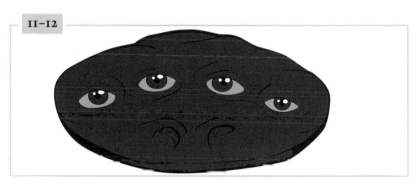

9. Roll out 4 flat ovals for eyelids and place them over part of the eyes, overlapping both the eyeball and the snake. Blend and shape into place, and sculpt until you get the look you want.

10. Bake the entire face piece on a baking sheet according to the clay package instructions. Let cool.

11. After cooling, add highlights to the eyes with white paint.

12. Paint dark brown around the face to create shadows. Set face aside to dry.

MAKING THE MOUTH

1. Mix equal parts red and dark brown clay to make a brick-red color for the gums.

2. To make the top of the mouth, cut three lengths of armature wire about 2 inches long. Cover them with the brick-red clay and roll into thicker snakes.

3. Roll out 5 more brick-red clay snakes to match the ones with wire.

4. Line all the snakes out side by side, with one wire snake on each end and one in the middle. This will give the "gums" more strength.

5. Join the snakes together, shaping them to look like the illustration. The finished piece should be about 2½ inches wide.

6-7

6. Find the middle of the box, and mold one end of your clay piece over the edge of the front cover, so that the "gums" are hanging over the edge.

7. Make a single indent on the end of each snake to make room for teeth.

8-9

8. For the bottom of the mouth, cut a rectangle out of the mesh wire sheet, about the same size as the top part of the mouth.

9. Rest the long end of the rectangle against the lip on the inside back cover of the book box, just underneath the top part of the mouth.

10-12

10. Fold the wire sheet up 90 degrees, just past the edge of the box.

11. Cover the wire sheet with the brick-red clay. Mold it to match the style of the top of the mouth.

12. Make 8 indents along the edge to make room for the teeth.

13-16

13. Wash your hands before making the teeth because you will be using white clay.

14. Roll out 16 small white balls.

15. Form each ball into a tooth. Try to vary the sizes a bit so that some teeth will be large and threatening, while others are smaller. Important! The teeth you want for the top should be larger than the bottom teeth.

16. Taper the end of each tooth a little and place each tooth into the indents you created on the other two mouth pieces.

17

17. Remove from the box carefully and bake both the top and bottom mouth pieces on a baking sheet according to package instructions. Let cool.

18. When fully cool, make a wash of dark brown paint thinned with water. Paint details around the teeth and gums using the wash.

20

19. Finally, paint a gloss medium over the mouth and teeth to make it look wet. Set the two mouth pieces aside to dry.

20. When dry, use the E6000 glue to attach to the box. Note that the mouth should sit to the right of the divot to make sure there's enough room for the tongue.

MAKING THE TONGUE

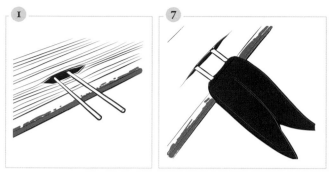

1. Use the armature wire to bore 2 holes into the divot on the side of your book box. Fill each hole with a wire about 1 inch long.

2. Use red clay to roll out a thick 1-by-2-inch piece. Sculpt the tongue shape with a fork at the end.

3. Gently slide the tongue onto the wires to poke holes in the clay.

4. Carefully slide off, then bake on a baking sheet according to package directions.

5. When cool, paint the center tongue detail using a bit of the same dark brown wash you used for the gums.

6. Let dry, and then coat in gloss medium.

7. Brush E6000 glue onto the wires, and slide the tongue in place.

MAKING THE TOP CLAWS

1. Roll out a sheet of gray-brown clay, about ⅛ inch thick.

2. Cut the sheet into ½-inch strips, and gently line the edge of the box's front cover with the strips to create a base for the claws. Make sure it doesn't go over the mouth pieces. Note that you'll have to remove these strip to bake, so don't secure them just yet.

3. Roll out a long ½-inch thick snake of gray-brown clay. Cut the snake into fourteen pieces: 2 2-inch pieces, 2 1 ½-inch pieces, 2 1 inch pieces, and the last eight reduce in size gradually until the last one is about ½-inch long.

4. Shape each snake piece into a tapered claw.

5. Insert a length of armature wire into the center of each claw, following the shape of the claw and leaving ½ inch of exposed wire at the top.

6. Press each claw into the clay base along the edge of the box. Be careful to press the exposed wire into the strip and cover completely with the clay. The largest two claws should go one either side of the middle where the mouth will go. The 1-inch claws will go on either side of those, with the 1 ½-inch claws at the corners. The last eight claws go on the short sides of the box—four on each side.

7. When finished, carefully remove from the box in sections and bake on a baking sheet according to the clay package directions. Set aside to cool.

8. When cool, attach the claws to the box using the E6000 glue.

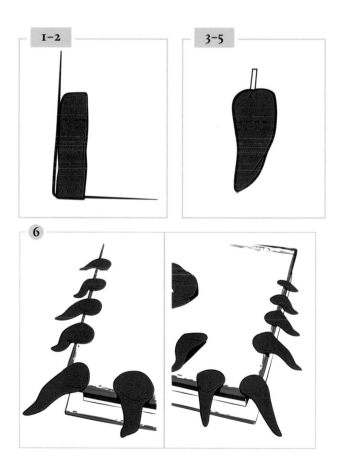

MAKING THE TENTACLES

1. Roll out a sheet of tan clay, about ⅛ inch thick. Cut into strips.

2. Place the clay strips gently all the way around the inside bottom edge of the box. (You're going to have to remove them to bake!) Don't overlap the mouth piece, but cut the rest to fit the lip on the bottom edge of the box.

3. Begin rolling another long snake of tan clay. Cut the snake into 16 pieces of varying sizes, with the longest being about 2 inches.

4. Form into tentacles similar to the way you shaped the claws.

5. Continue with the same building procedure as the claws, making sure to fit a length of armature wire in each of the tentacles for strength but leaving enough to insert into the base strip.

6. Roll out a very thin sheet of gray-brown clay, and cut out triangle shapes to fit under each of the tentacles.

7. Attach the gray-brown triangles to the bottom of each tentacle.

8. Roll out small balls to add suckers: 3 for each of the larger tentacles, and 2 for smaller tentacles.

9. Flatten each ball, and press down in the center to make a ring. Place each ring on the tentacles.

10. Attach the tentacles to the box by pressing them onto the base layer, making sure to cover the armature wire. The longest ones should go in front. Add clay to the back spine as well to make sure it will have a good hold when it bakes.

11. Carefully remove in sections, and bake. Let cool.

12. When cool, make a wash by thinning dark brown paint with water and brush it around the edges of the suckers to give them depth. You can also add a bit of pink wash around the suckers' base to add detail.

13. Once dry, use the E6000 glue to attach the tentacles to the box.

MAKING THE TITLE PIECES

1. Roll out a sheet of gray-brown clay, about ⅛ inch thick.

2. Cut out 2 pieces large enough to fit "The Monster Book of" according to template on page 90.

3. Bake.

4. If using a cutting machine, download the template at www.insighteditions.com/craftingwizardry and cut out using the machine.

Follow steps 10 through 12 from the Transfiguration Textbook project (page 74).

5. Seal with matte decoupage glue

ALTERNATE METHOD

1. Lay tracing paper over the template and trace with a pencil.

2. Remove the template, turn the tracing paper over, and trace the back.

3. Put the back face down (so the words are the right way round) and gently go over the design again with a stylus. (A pencil could also be used.)

4. Fill in the outline with a gold paint pen and let dry.

5. Seal with matte decoupage glue.

FINISHING THE BOOK

1. Use fabric scissors to cut a piece of faux fur 18 by 9¾ inches.

2. Lay the faux fur onto the box, fur side down.

3. Place the eyes and title pieces on the back side of the faux fur for placement, and carefully trace around the pieces using a permanent marker.

4. Remove the eyes and title pieces, and draw a second line ¼ inch inside the traced lines. Cut out along inner lines.

5. Cover ½ inch around the edges of the box with painter's tape. Make sure to cover the claws, mouth pieces, and tentacles.

6. Spray the top of the box and the spine with adhesive spray.

7. Spray the back side of the faux fur with adhesive. Before spraying, tuck the fur under the edge to avoid getting glue on the outer strands.

8. Let dry until tacky.

9. Line up the corners of the faux fur and the box, and wrap the faux fur around the spine and top, fur side up. Do not allow the fabric to distort where it has been cut out, and smooth into place. Do not cover the painter's tape yet.

10. Spray the back of the book box, let dry until tacky, and smooth the faux fur into place.

11. When set, remove the painter's tape.

12. With hot glue, dab the remaining ½ inch of faux fur, and glue to the box, fitting the fur over the claws and tentacles.

13. Use the E6000 glue to glue on the eyes and title pieces into the holes on the fur.

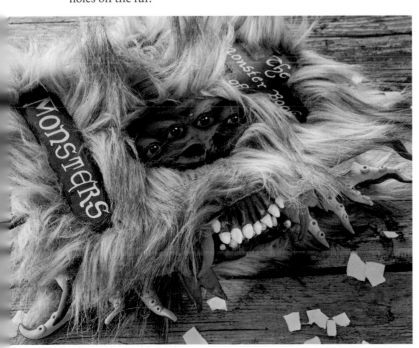

The Monster Book of Monsters

Behind the Magic

In the end credits for *Harry Potter and the Prisoner of Azkaban*, there is one room labeled "Book of Monster's Repair Workshop" on the Marauder's Map.

⁝✶⁝

"And open your books to page 49."
"Exactly how do we do that?"
"Just stroke the spine, of course!"

Rubeus Hagrid and Draco Malfoy, *Harry Potter and the Prisoner of Azkaban*

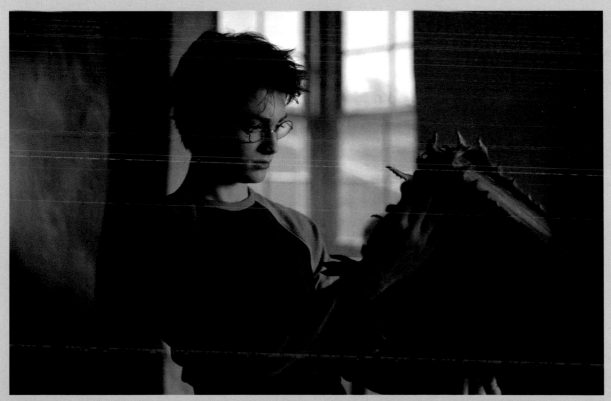

ABOVE: Harry Potter (Daniel Radcliffe) manages to hold his Monster Book of Monsters closed in *Harry Potter and the Prisoner of Azkaban*.

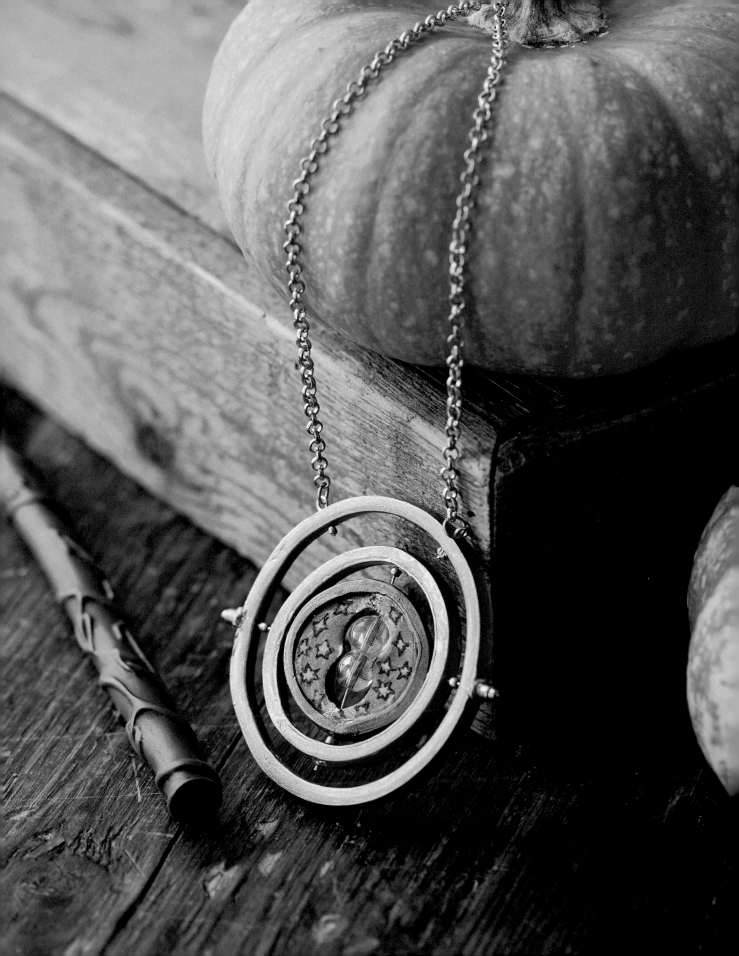

HERMIONE'S TIME-TURNER

Designed by **JILL TURNEY**

SKILL LEVEL ⚡⚡⚡⚡

I t's undisputed that Hermione Granger is an incredible student. She loves books, exams, and any mental challenge, which is why Harry Potter's godfather, Sirius Black, calls her "the brightest witch of her age." When Hermione desires to take more classes in her third year at Hogwarts than the normal curriculum, Gryffindor Head of House Minerva McGonagall supplies her with a Time-Turner. Time-Turners are magical devices that allow one to travel back in time—this way Hermione can take one class, then use the Time-Turner to take another class taught at the same time.

Hermione needs to be discreet about using the Time-Turner, and so designer Miraphora Mina knew the piece had to be on the small side and lie flat, because she wears it as a necklace. Mina's inspiration came from an astronomical instrument called an astrolabe, which is composed of collapsible rings. "I also wanted a moving element," says Mina. "So when she uses it, it comes alive; it becomes 3D because it's really a ring within a ring that opens up to allow part of it to spin." The time it takes to make Hermione's Time-Turner is time well spent!

WHAT YOU NEED:

- Scissors
- Parchment paper
- Compass (optional)
- Metal ruler
- Masking tape
- Pencil
- Baking sheet
- One 2-ounce package gold polymer oven-bake clay
- Two 4-millimeter nail files
- Craft mat (for rolling out dough)
- Rolling pin
- Utility knife
- Toothpick or sculpting tool
- Two 3-inch gold-colored head pins
- 24-gauge copper wire
- Wire cutters
- Two ⅜-inch clear glass round beads
- Hot glue gun
- Cap of an ultrafine-point permanent marker, such as Sharpie®, or ⅜-inch circle cutter
- 1-inch plastic paint pot
- Oven mitts
- Cooling racks
- Two 1-inch gold-colored eye pins
- 2 gold-colored crimps
- Crimping tool
- 2 gold-colored jump rings
- 18-inch gold-colored chain with clasp
- 4 gold-colored seed beads
- 2 gold-colored earring backs
- Paintbrush
- Black and brown fine-nib permanent markers, such as Sharpie®
- White acrylic paint

OPTIONAL
- Brilliant metallic luster gold water-based paint

Time-Turner Diagram

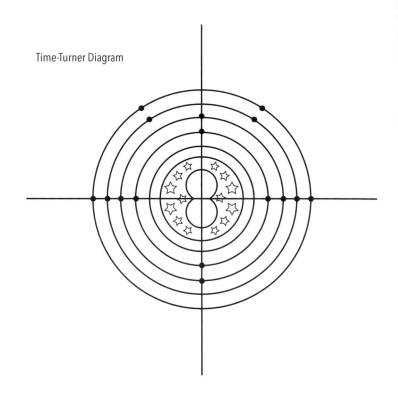

1. Cut a 4- to 6-inch piece of parchment.

2. Lay the paper over the diagram printed here: Tape down the paper, and trace the black axis, circles, and dots. This will go faster if you use a compass and ruler. Align the compass point in the center of the cross, and draw your circles out from there. The dots indicate where to poke the holes, so don't forget to add those, too. The axis lines will help you align the poked holes.

3. Remove the tape, and lay the paper on the baking sheet.

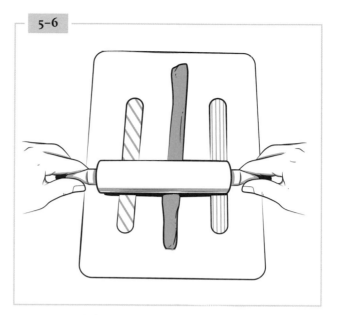

4. Unwrap the clay from the packaging. Knead the clay for a while to get it malleable.

5. Once workable, roll the clay into a thick rope shape.

6. Lay down the nail files flat onto your craft mat parallel to each other, about 4 inches apart. Place the clay rope in the middle.

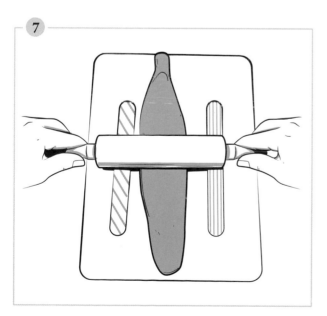

7. Rest the rolling pin on the nail files, and roll it back and forth along the length of the files while rolling the clay rope flat. Roll until the rope is flattened to the height of the nail files. The length should be at least 8 inches.

8. Move the nail files out of the way.

9. Using the edge of the metal ruler, slice off a piece of clay on either long side to create a straight edge.

10. With a toothpick, mark ⅜ inches at the left and right side of the straight edge, and align the thin edge of the ruler on those points. Press down and slice.

11. Repeat step 10 to make another strip the exact same ⅜-inch width.

12. Lay one of the strips over the top of the middle ring of your traced diagram. Try to get it as close a perfect circle as you can. Overlap the ends (A).

 With a utility knife, cut both ends diagonally (B).

 Remove the sliced-off ends and put them aside (C).

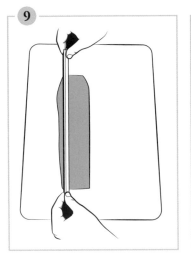

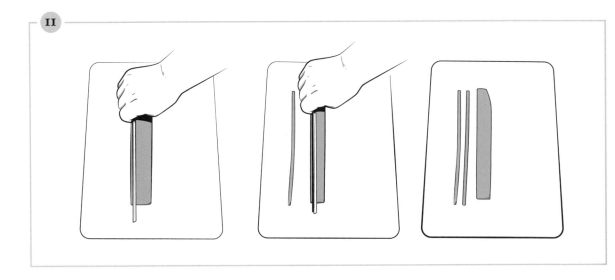

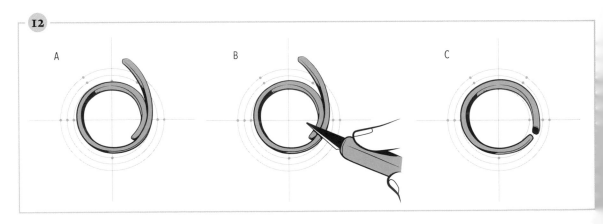

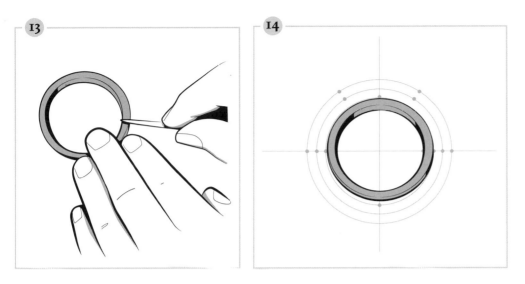

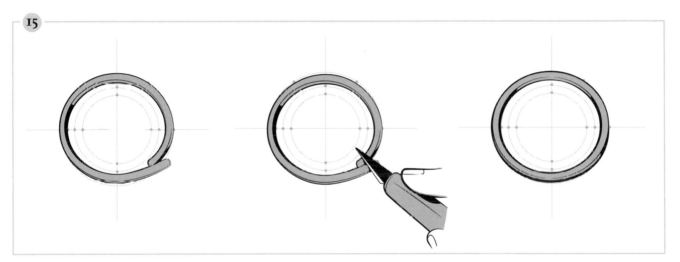

13. Join the 2 diagonally cut ends. Smooth together with a toothpick. Turn the ring over and smooth the other side as well.

14. Realign the clay strip on the parchment paper so it's as near a perfect circle as possible. Use the diagram as your guide. Carefully move the ring off the diagram before moving on to the next step of making the outer ring.

15. Lay the second clay strip around the outer circle in the diagram (A).

 Use the same overlapping ends and diagonal cut as you did with the first ring (B).

 Smooth the ends together and realign to make a perfect circle (C).

16. Place the middle clay ring back on the diagram, and align it as close to a perfect circle as possible. Center it inside the outer circle (the open space between the 2 rings should be as even as possible).

TIP: When placing the rings on the diagram, make sure the joined ends are not on top of any of the dots. The joints are less structurally sound and could cause the rings to break if they are poked with holes at those points.

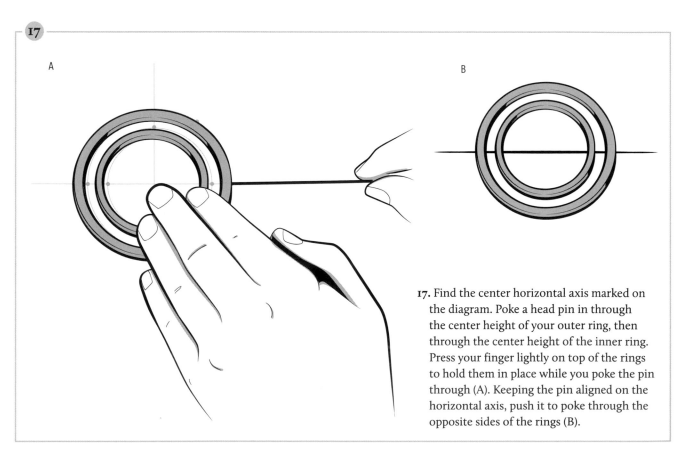

17. Find the center horizontal axis marked on the diagram. Poke a head pin in through the center height of your outer ring, then through the center height of the inner ring. Press your finger lightly on top of the rings to hold them in place while you poke the pin through (A). Keeping the pin aligned on the horizontal axis, push it to poke through the opposite sides of the rings (B).

18. Slowly pull the pin all the way out. Gently remove the outer ring and place it out of the way on the baking sheet.

19. Realign the inner ring so it matches the circle shape on the diagram.

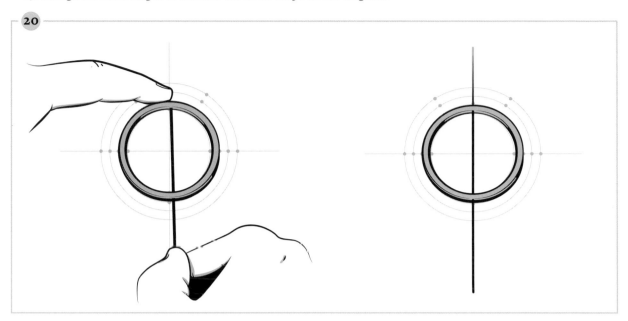

20. Find the center vertical axis marked on the diagram. Poke a head pin in through the center height of the ring at the bottom, then follow the vertical axis and poke the head pin through the center height at the top of the ring. Press your finger lightly on top of the ring to hold it in place while you poke the pin through.

21. Remove the pin, then move the ring off the diagram.

22. Realign the outer ring back on the diagram. Make sure the holes you made earlier in the ring match up with the dots along the horizontal axis on the diagram. Using the 2 head pins, poke through the ring where the diagram dots are at the top. These holes will be used for the chain attachment. Remove the pins, and place the inner ring back on the diagram. Keep the rings in place on the parchment paper on the baking sheet, and set it aside for now while you work on the center medallion.

MAKING THE SAND TIMER

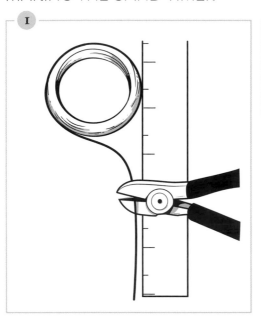

1. Cut a 3-inch piece of the 24-gauge wire with your wire cutters. Manipulate the wire until it's as straight as possible.

2. Thread 2 clear round beads on the wire, and center them.

3. Hot-glue the beads together.

CREATING THE SAND TIMER MEDALLION

3. Use the cap of the ultrafine-point marker or a ⅜-inch circle cutter to cut a circle out of the clay.

1. Gather up the unused pieces of clay, and knead into a ball.

2. Place the clay on your craft mat, and roll it out as thin as a crepe.

4. Cut another circle intersecting with the first to make an 8 shape.

5. Repeat steps 3 and 4 to make another 8 shape about 2 inches to the right of the first 8 shape.

6. Lay the beads and wire in the first 8 shape.

7. Fold the clay vertically, lining up the two 8s and sandwiching the wire in between the clay layers. Lightly press the clay to secure the 2 layers. Turn the clay over and press the other side.

8. Take the lid off the 1-inch plastic paint pot. Center the pot over the top of the 8 shape.

9. Lightly press and twist the pot to make an indentation, then remove.

10. Using your utility knife, cut along the edge of the indentation with a sawing motion (poking the knife up and down along the indentation). Don't cut the wire!

11. Peel out the cut circle and the wires from the surrounding clay.

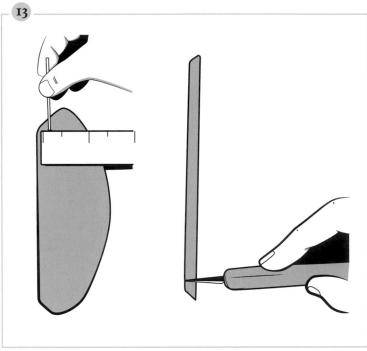

12. Roll out another piece of clay the thickness of a popsicle stick. Cut a straight edge with your metal ruler.

13. Cut a ¼-inch strip, and square off one end. Take your toothpick and make a small round divot in the center of the strip's end.

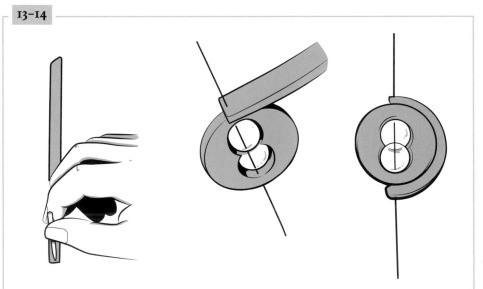

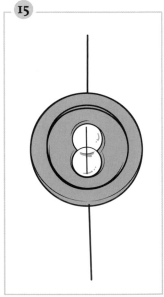

14. Place the divot around the wire at the top of the medallion. Wrap the strip along the edge of the medallion, and cut it when you get to the bottom wire. Wrap it around the wire. Smooth the strip along the medallion to secure the clay pieces together.

15. Repeat for the other side. Use a toothpick or your sculpting tool to smooth the ends together.

BAKING

1. Preheat oven to 275°F.

2. Place the finished medallion alongside the rings on the baking sheet. Check the rings to make sure they're aligned on the diagram and as close to perfect circles as possible.

3. Put the baking sheet in the heated oven, and set the timer for 15 minutes.

4. When done, remove with oven mitts, and set to cool on a cooling rack. Turn off the oven.

OPTIONAL: Once your clay pieces are cool, you can use a fine-grit sandpaper or your nail file to sand out any imperfections in the clay.

FINAL ASSEMBLY

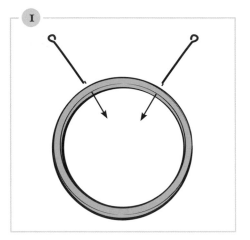

1. Poke the 2 eye pins into the 2 holes at the top of the outer ring.

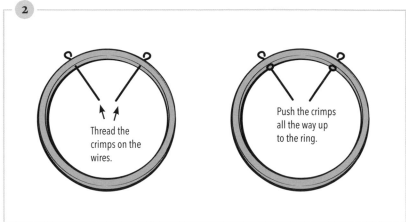

Thread the crimps on the wires.

Push the crimps all the way up to the ring.

2. String the crimps onto the ends of the eye pins, and push them all the way up to the clay ring.

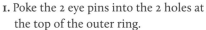

Crimp the crimps flat.

3. Flatten the crimps tightly with the crimping tool. Squeeze hard! The crimps should be as close to the clay as possible, and the eye pins should not be able to be pulled out.

Trim the wires.

4. Trim off the eyepin wire below the crimps with your wire cutter.

Open the jump rings.

Thread the jump rings through the eye pinholes.

5. Grab the 2 jump rings. Open each one by holding the sides of the ring and twisting slightly until there's a gap between the 2 ends. Thread each one into the eyes of the eye pins.

6

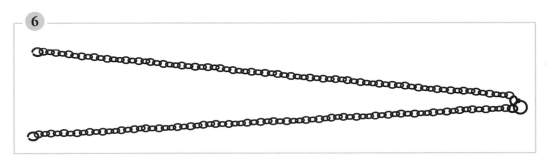

6. Using your crimpers, open up the bottom ring in the chain necklace. Remove so you have an open-ended chain.

7

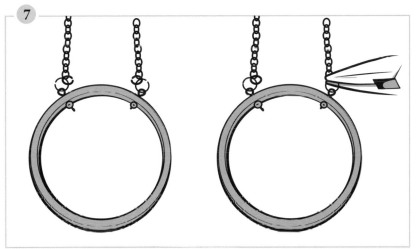

7. String the bottom rings of the chain onto the jump rings. Use your crimping tool to close the jump rings.

8

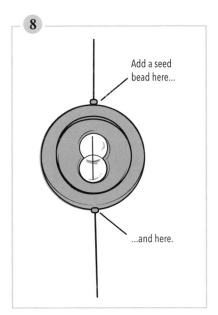

Add a seed bead here...

...and here.

9

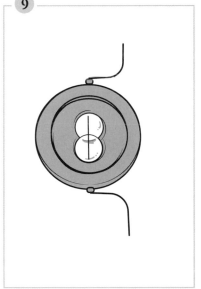

8. Grab your Sand Timer Medallion and seed beads. String a seed bead onto the top and bottom wire.

9. Bend the wires to the right, and then into an L shape.

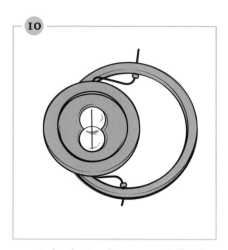

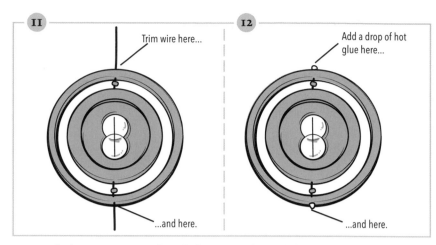

10. Poke the Sand Timer Medallion's wire ends into the vertical axis holes of the inner ring. Make sure the wire ends poke out to the outer side of the ring.

11. With the crimpers, gently pull the wire ends until they straighten out and the medallion lies flat and is centered within the ring. Trim the wire ends flush to the outer edge of the ring.

12. Add a drop of hot glue at both ends to secure the wire in place.

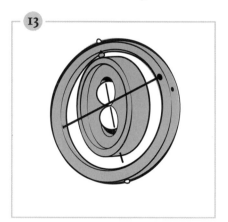

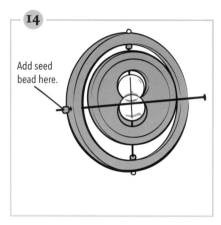

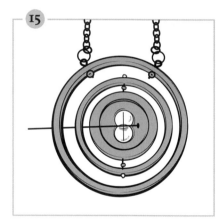

13. Rotate the Sand Timer Medallion slightly, and poke a head pin into the ring's horizontal axis hole. Let the wire end poke just slightly beyond the outer edge of the ring.

14. String a seed bead on the end of the wire.

15. Place the inner ring inside the outer ring, and poke the head pin through the matching horizontal axis hole on the outer ring. Push it all the way through until the pin head rests against the inner ring.

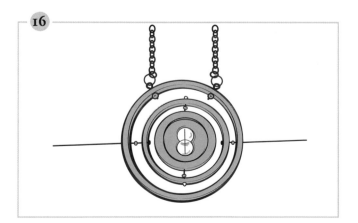

16. Repeat steps 13 through 15 on the other side of the horizontal axis. Adjust the pins until the inner ring is centered inside the outer ring.

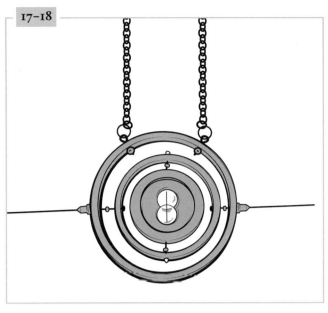

17-18

17. Push an earring back onto each of the extended wires. Add a drop of hot glue, and nestle them snug against the outer ring.

18. Trim the wires close to the earring backings.

19. Optional: Paint the clay pieces with gold paint. Allow to dry.

20. Draw some multisided stars with a brown permanent fine-line marker around the top surface of the Sand Timer Medallion. With a black marker, add some shadows to make the stars look like they're cut out of the clay. Paint white in the center of the stars with a tiny brush.

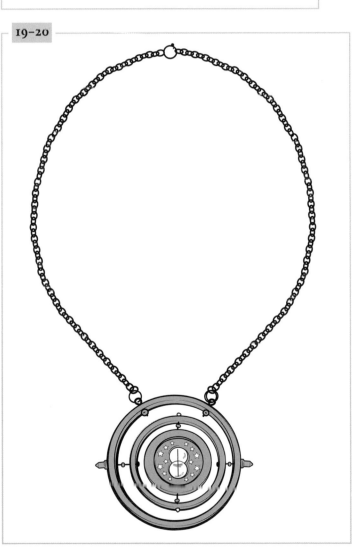

19-20

Behind the Magic

Mottoes about time are engraved on the Time-Turner's rings. The outside ring reads: "I mark the hours every one, nor have I yet outrun the sun," and the inside ring says: "My use and value unto you depends on what you have to do."

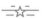

"DON'T BE SILLY. HOW COULD ANYONE BE IN TWO CLASSES AT ONCE?"

Hermione Granger,
Harry Potter and the Prisoner of Azkaban

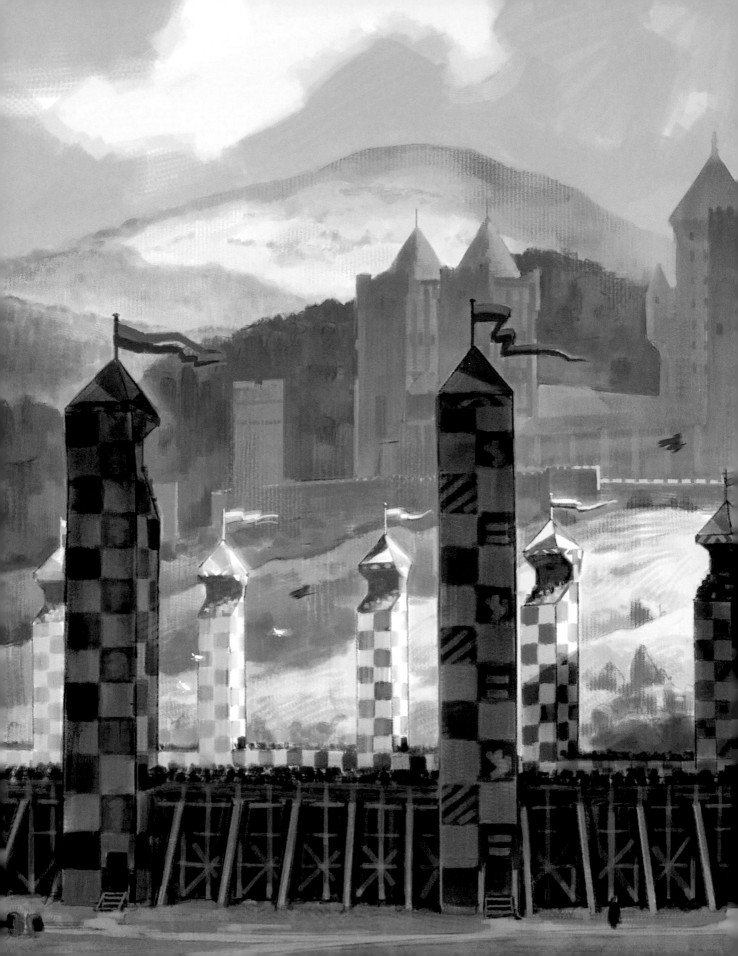

CHAPTER 3:
CLUBS & COMPETITIONS

"Another year gone. And now, as I understand
it, the house cup needs awarding, and the
points stand thus . . ."

Albus Dumbledore, *Harry Potter and the Sorcerer's Stone*

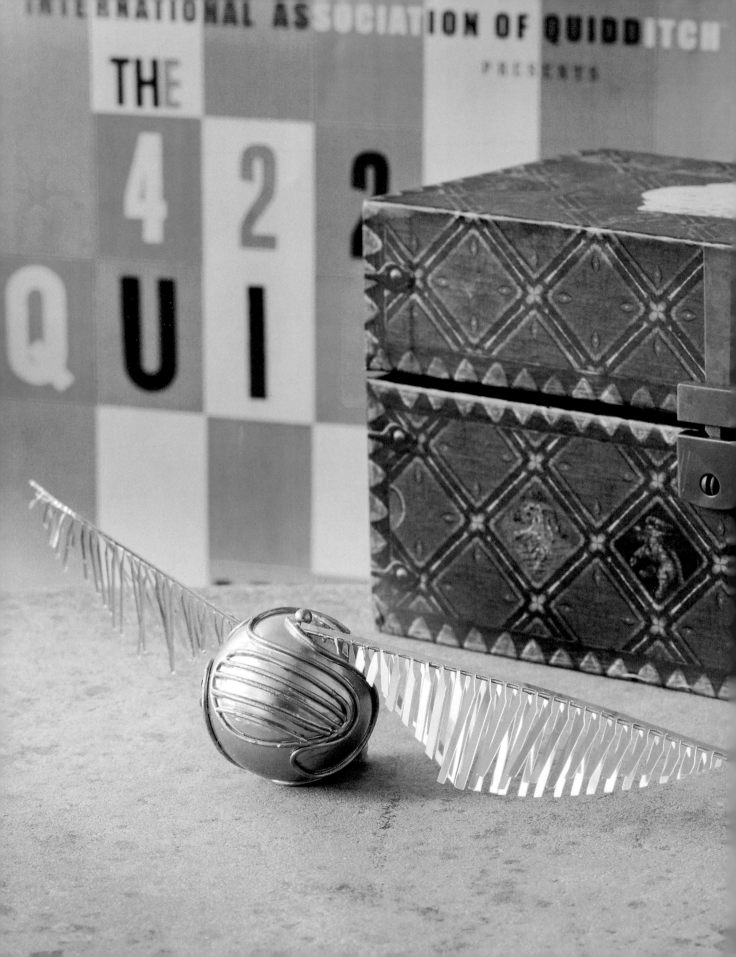

THE GOLDEN SNITCH

Designed by **HEATHER VAN DOORN**

SKILL LEVEL ⚡⚡⚡

Every year, the four houses of Hogwarts compete for the Quidditch House Cup, awarded to the team with the most points at the end of the season. This favorite sport of the wizarding world involves high-speed aerial work, balls that are charmed to knock players off their brooms, and a chance to end the game quickly by catching the Golden Snitch. A walnut-sized sphere, the Snitch sports a pair of wings that enable it to zip, zap, soar, hover, and tease its pursuers, called Seekers, with its spontaneity. Harry Potter's talent on a broomstick is recognized during his first flying class, and he becomes the youngest Seeker in a century, helping the Gryffindor team to multiple victories.

In developing the design for the Golden Snitch, which was crafted for both practical and digital forms, concept artists explored aerodynamic ideas for the shape of its wings, looking to nature in the form of moth wings or fish fins, and to outdoor sports with profiles resembling sails and rudders. The final wing design is made up of thin, vertical strips that form a modified sail shape. One hundred and fifty points to you for making this Golden Snitch!

WHAT YOU NEED:

- Ping-pong ball
- Pencil
- Scissors
- Inexpensive earbuds (these will be used for their wire only)
- Gloves
- Super glue
- 2 standard-size paper clips
- Wire cutters (or nail clippers)
- Two 3mm beads
- Foam board or thick cardboard to use during painting
- Gold metallic spray paint formulated for plastic (if not using paint formulated for plastic, you'll need primer spray paint too)
- Craft knife
- 2 sheets gold foil or Mylar paper
- E6000 glue
- Toothpick

1. The body of the Golden Snitch features a distinctive pattern. Use the example images to sketch the pattern onto the ping-pong ball lightly with a pencil.

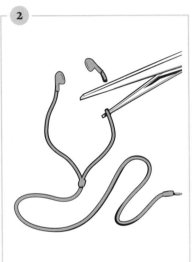

2. Use scissors to cut the earbuds off their wires, then pull the 2 strands of wire apart. Cut off about 1½ feet of covered wire to use.

3. Wear gloves for this step: Super-glue the wire to your ping-pong ball along the lines of the pattern you just drew.

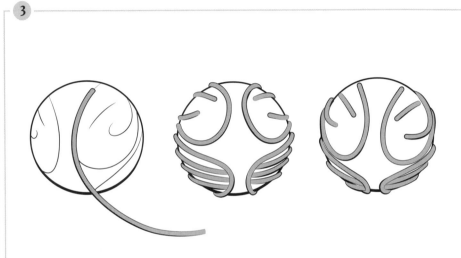
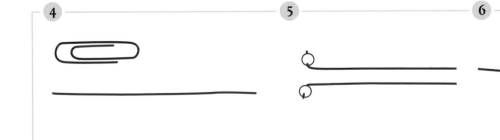

4. Next, unfold and straighten the paper clips. Then trim with wire cutters (or nail clippers) so each is 4½ inches long.

5. Make a small L-shaped bend at one end of each paper clip. Insert a bead onto each bend.

6. Insert the wire from the beaded end of each paper clip into the top left and right sides of your ping-pong ball. Super-glue into place.

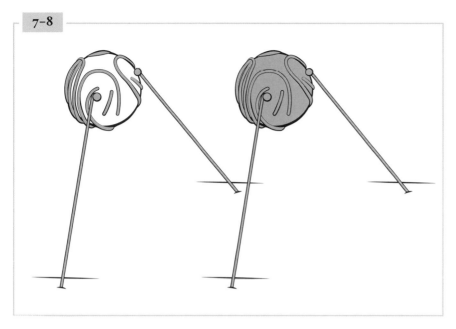

7. Use the paper clips to hold up the ping-pong ball by placing the ends on a foam mat or piece of cardboard, like shown.

8. Spray-paint the ping-pong ball and paper clips gold. Make sure to paint in light coats, and allow to dry completely before adding another coat. If you don't have the spray paint made for plastic, use a primer spray paint before painting the gold.

9. Using a craft knife, cut out 2 wings from the Mylar using these illustrations as your guide. If you have a digital cutting machine, you can download a template online at www.insighteditions.com/craftingwizardry.

10. Score your wings lengthwise down the center carefully, and fold in half. Make sure you don't cut all the way through. The Mylar used in the example craft is gold on one side and silver on the other; if you're using the same paper, make sure the gold is on the outside of the wing.

11. Attach one wing to each paper clip by putting a thin line of E6000 glue along the top of the paper clip and folding the wing over it. Use a toothpick to help lay the glue.

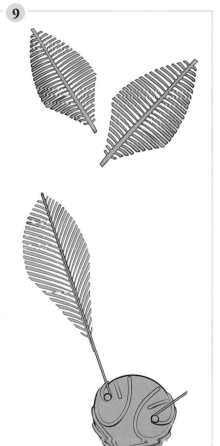

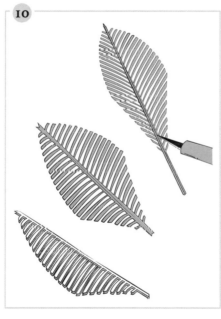

Behind the Magic

Playing off its diminutive but powerful wings, the sound design team chose a hummingbird-like buzz for the Golden Snitch.

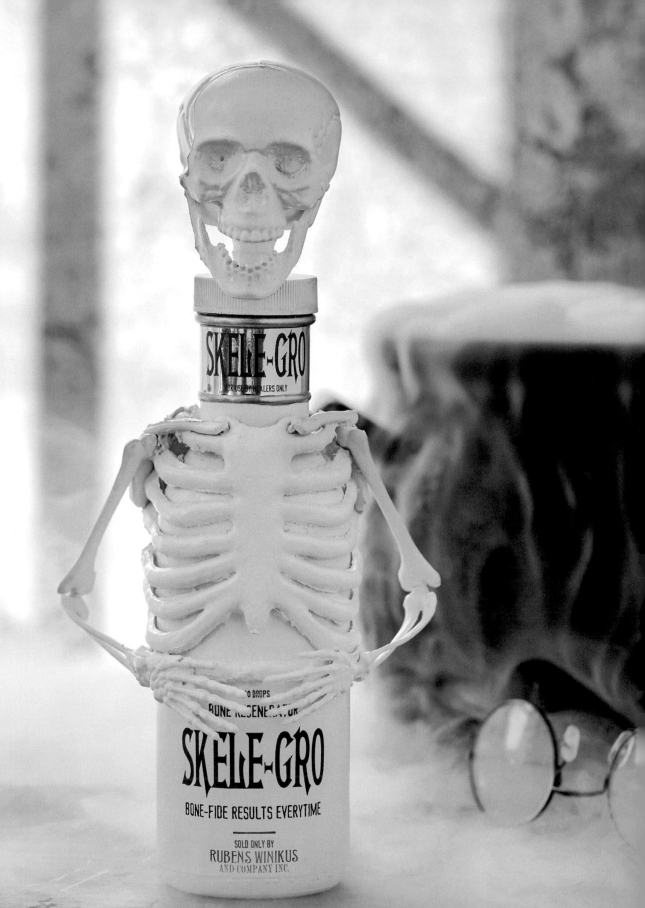

SKELE-GRO BOTTLE

Designed by **VANESSA BRADY**

SKILL LEVEL ⚡⚡

The sport of Quidditch can be brutal: A player's arm might end up with broken bones. But after one game, in *Harry Potter and the Chamber of Secrets*, Gryffindor Seeker Harry Potter is left without *any* bones in his arm! During a rough game against Slytherin, Harry is further challenged by a rogue Bludger that crashes into his arm as he reaches for the Golden Snitch. Harry manages to catch the Snitch in his left hand before he hits the ground (and wins the game), but the Bludger continues to assail him until Hermione explodes it using *Finite Incantatem*. Professor Gilderoy Lockhart races to the rescue, claiming he can fix Harry's arm. Lockhart casts *Brackium Emendo,* and Harry no longer needs to worry about broken bones—the bones in his arm are gone! Harry is rushed to the hospital wing, where Madam Pomfrey opens a bottle of Skele-Gro. This elixir makes it possible to grow the bones back, but it will be painful. "You're in for a rough night, Potter," Pomfrey warns him. "Growing bones is a nasty business." The prop department created a bottle with a skull-shaped stopper that has a bit of the upper vertebrae descending into the bottle neck. The body of the bottle is enveloped in a rib cage, with handles in the shape of human arm bones—a truly humerus design.

WHAT YOU NEED:

- Recycled salad dressing bottle
- Scissors
- 15-inch plastic skeleton
- Hot glue gun and glue sticks
- White spray paint
- Gold acrylic paint
- Paintbrush
- Skele-Gro labels (included on sticker sheet at the back of this book)
- Gold printer paper
- White printer paper
- Double-sided tape
- Cream acrylic paint

1. Clean and remove any labels from the recycled bottle.

2. Carefully cut the arms, head, and ribcage off the skeleton.

3. If it fits, slide the skeleton's rib cage over the top of the bottle to rest around the middle of the bottle. You may have to cut the rib cage open in the back to fit if it doesn't easily slide over.

4. Apply hot glue to the inside of the plastic rib cage, and press to the bottle to secure.

5. Use hot glue to make a ridge just below the rib section.

6. Glue the skeleton arms in place at the top of the rib cage with the hands resting on the ridge.

7. Apply glue to the neck to secure the head to the top of the bottle lid.

8. Apply a coat of white spray paint to all the pieces. Repeat until completely covered.

9. If your bottle has raised ridges at the top and bottom of the bottle's neck, skip this step. Otherwise, use hot glue to create ridges around the top and bottom of the bottle's neck.

10. Paint these raised sections on the bottle's neck with gold paint.

11. Apply the gold and white Skele-Gro labels to your bottle (stickers included on a sheet in the back of this book).

12. Dab and blend the cream acrylic paint onto the skeleton to make it look more like bones.

BEHIND THE MAGIC

The Skele-Gro bottle's label, created by the film's graphics department, included the claim that the Bone Regenerator offers Bone-Fide Results Every Time, a play on *bona fide*, the Latin term for *genuine*.

"I CAN MEND BROKEN BONES IN A HEARTBEAT,
BUT GROWING THEM BACK. . ."

Madam Pomfrey, *Harry Potter and the Chamber of Secrets*

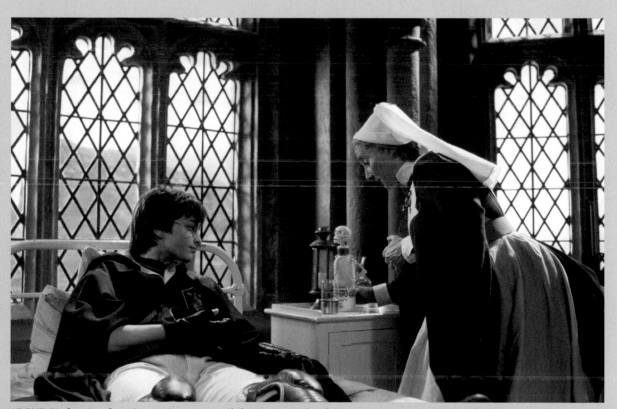

ABOVE: Madam Pomfrey (Gemma Jones) pours Skele-Gro into a glass for Harry Potter's (Daniel Radcliffe) first dose of the potion in *Harry Potter and the Chamber of Secrets*. The taste is a far cry from pumpkin juice!

PATRONUS CHARM LIGHTED SHADOW BOX

Designed by **VANESSA BRADY**

SKILL LEVEL ⚡⚡⚡

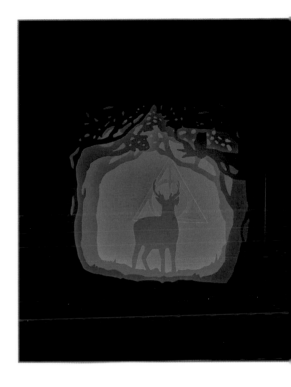

While Ron, Hermione, and Harry are on the train to their third year at Hogwarts in *Harry Potter and the Prisoner of Azkaban*, they are threatened by Dementors: Dark creatures that drain every positive feeling from their victims. Fortunately, they're sharing their cabin with that year's new Defense Against the Dark Arts professor, Remus Lupin, who casts *Expecto Patronum* to repel the wraith-like beings. Harry is so deeply affected by Dementors that Lupin teaches him the Patronus Charm, a protective "armor" the Dementor can feed on instead of the wizard. There are two types of Patronus—a shield form, which appears as a glowing, silvery mist, and a corporeal form that takes the shape of an animal guardian.

In *Harry Potter and the Order of the Phoenix*, Harry becomes the de facto leader of Dumbledore's Army, a group of students he tutors when their fifth-year Defense Against the Dark Arts professor, Dolores Umbridge, refuses to allow her pupils to study defensive magic. After weeks of secret lessons, Harry teaches them the Patronus Charm, and several of the students successfully cast corporeal Patronuses: Ginny, a horse that gallops; Ron, a Jack Russell terrier that mows down Neville Longbottom; and Luna Lovegood, a hare that bounces from wall to wall. Digital artists gave these moving Patronuses rippling textures, energy lines, and ribbons of light that spiraled behind them. This shadow box portrays Harry Potter's Patronus—a stag, the same as that of James Potter, his father.

WHAT YOU NEED:

- Patronus Templates (pages 120–121)
- Tracing paper
- Double-sided tape
- Pencil
- White cardstock
- Craft knife
- Glue
- Wooden dowel (¼-inch diameter)
- Shadow box frame with matte board (shadow box used here is 12 x 12 x 2 inches)
- Battery-powered LED strip lights

1. Lay a piece of tracing paper over template A. Tape down the paper along the edges, and trace with a pencil.

2. Lay the tracing paper over the center of a sheet of cardstock, and using a craft knife, carefully cut out the template.

3. Repeat steps 1 and 2 for templates B, C, and D.

4. Cut a wooden dowel into 4 pieces of equal length, each as long as the sides of the shadow box. Then cut the 4 pieces in fourths to make 16 small spacers.

5. Tape four wood spacers to the back of each cut cardstock piece for templates A, B, C, and D.

6. Layer each cardstock piece into the shadow box in order. Add a blank cardstock piece after piece D.

7. Adhere the LED strip to the sides of the frame. Secure the battery pack inside the frame with the strong double-sided tape.

8. Cut out a rectangle from the back of the frame so that the battery switch is easily accessible.

A

B

C

D

ᗷEHIND THE Ɱ AGIC

Digital artists ensured that the light from the Patronuses cast by Dumbledore's Army illuminated the walls in the Room of Requirement, and were reflected in the mirrors and windows of their clandestine classroom.

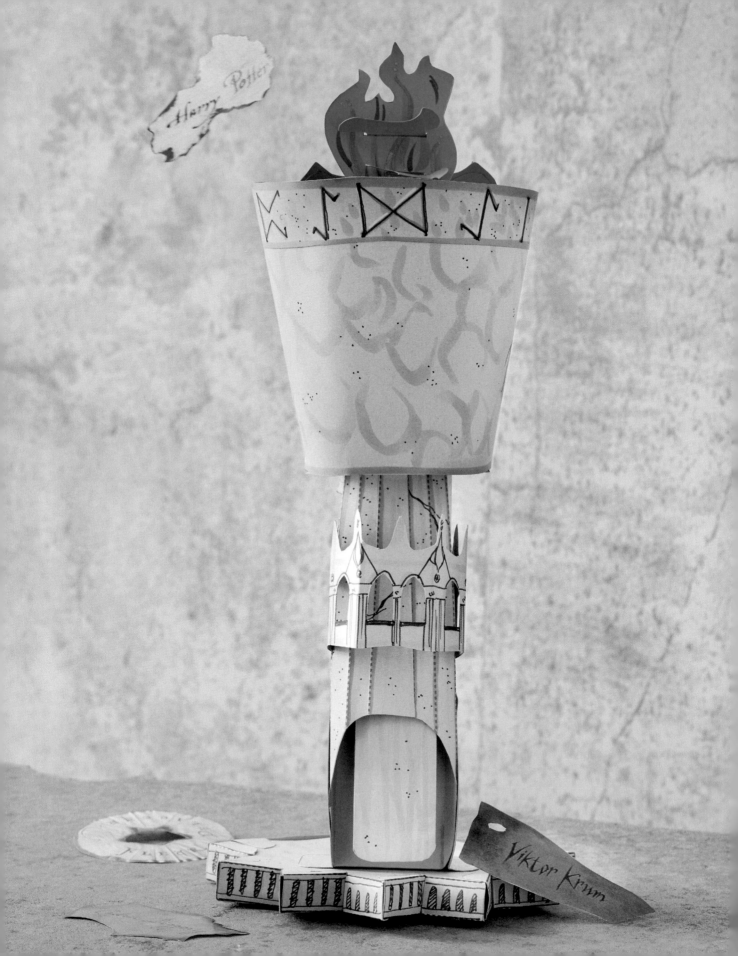

Pop-Up Goblet of Fire

Designed by **MATTHEW REINHART**

SKILL LEVEL ⚡⚡⚡

The Triwizard Tournament, a magical competition between three European wizarding schools, is hosted by Hogwarts School of Witchcraft and Wizardry in *Harry Potter and the Goblet of Fire*. Once the lovely ladies of Beauxbatons Academy of Magic and the proud sons of Durmstrang Institute arrive, Albus Dumbledore dissolves a five-tier jeweled casket to reveal the Goblet of Fire. Anyone wishing to enter the tournament can write their name upon a piece of parchment and throw it into the flickering blue flames of the goblet in hopes of becoming their school champion.

The five-foot-tall goblet was carved from a thick limb of English elm. "We found the best bit of timber we possibly could," says production designer Stuart Craig, "with burrs and twists and knots and splits in it." The rim of the goblet is circled by runes, and its stem and base are ornamented with intricate carvings of a Gothic style that echo the architecture of Hogwarts.

When each champion for the competition is selected, the goblet's blue flames turn red and shoot out the parchment bearing the champion's name. Three times the flames turn red, for Fleur Delacour of Beauxbatons, Viktor Krum of Durmstrang, and Cedric Diggory of Hogwarts. Then, to the shock of all those present, the flames turn red a fourth time, and a fourth champion is chosen— Harry Potter!

WHAT YOU NEED:
- Pop-Up templates (pages 175–181)
- Ruler
- Cutting tool, such as a craft blade
- Glue
- Colored paper, markers, decorative tape, etc. (for decoration)

1. Punch out the templates on pages 175–181.

2. Fold the template pieces on all the creased lines. Press firmly to make crisp folds.

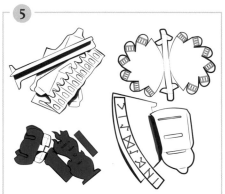

3. If desired, use the shape of the goblet to cut an extra strip of paper for the brim of the cup. You can also just draw a brim on the cup during decoration and skip this step.

4. Decorate any desired pieces before assembly. It's easier to do this when the pieces are flat.

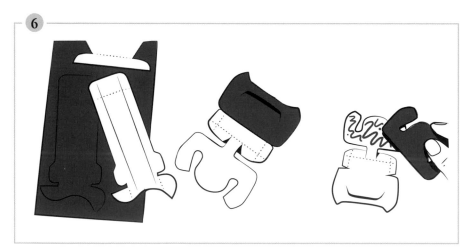

5. Before assembly, group pieces by type to help keep track of everything. Group the flame pieces (A, C, G, H, and L), the goblet pieces (B, D, and K), the base piece (I), and stem pieces (E, F, and J) together.

6. For the blue flames (A, C, G, H, and L), you can color both sides of the pieces blue, or you can use the templates to cut those shapes out of blue paper. If you cut the shapes out of blue paper, be careful to mark all score and cut lines accurately to prevent any issues with the pop mechanism.

ASSEMBLING THE FLAME

1. Glue corresponding tabs to the gray spaces on the template.

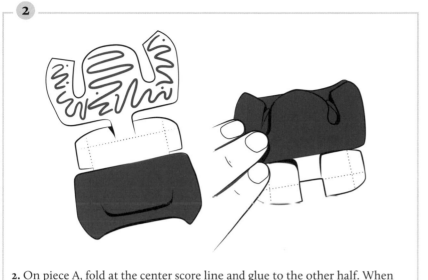

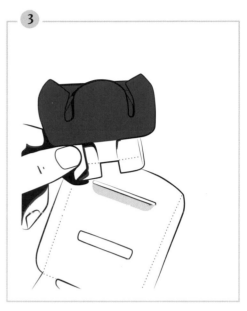

2. On piece A, fold at the center score line and glue to the other half. When gluing this piece, make sure not to glue the slit closed. Another piece will insert through here.

3. Fold tabs on piece A along score lines so it can fit through the narrower top slit on piece B.

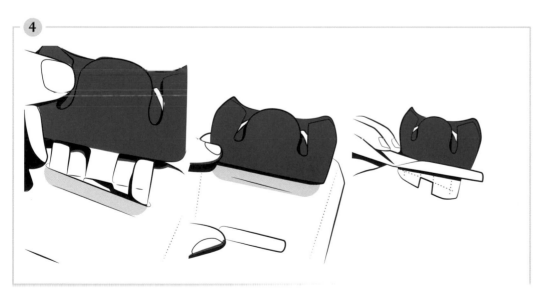

4. Fully insert piece A into the tab on piece B, then unfold the tabs on piece A so it stays in place. This is the back of the flame, and it attaches to the inside of the back of the goblet.

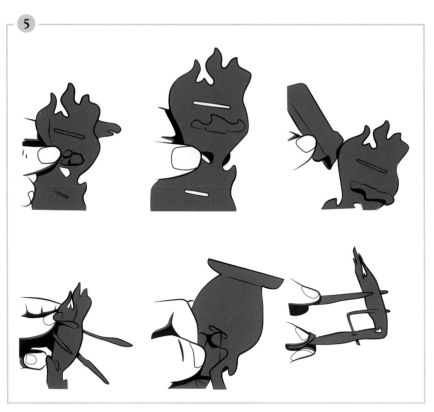

5. Insert piece L into the second slit on piece C from the back, then unfold the tabs on piece L to hold in place. Glue piece G to piece H on the corresponding gray-shaded area for support. Insert piece H into the topmost slit on piece C, unfolding the tabs on piece H to hold in place. Fold piece L at the center score line, and insert the other end into the bottommost slit on piece C from the back.

6

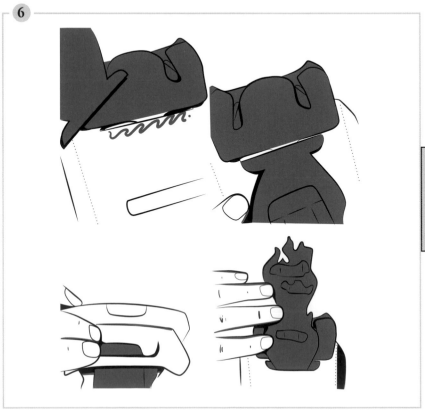

6. Glue the base of piece C to the corresponding gray-shaded area on piece B. It's toward the top, underneath where you inserted piece C. Insert the exposed end of piece H into the slit on piece C, then glue the tab to the shaded spot on piece B.

NOTE: When pressed down, this entire mechanism should lie completely flat. If it does not, a piece is misaligned or has been folded in the wrong place.

ASSEMBLING THE PULL TAB AND STEM

1. Fold piece J at the score line and glue together. This adds strength.

2. Flip piece B over (flame side down), and lay it so the round end is at the bottom. Glue the rectangular top part of piece E to the middle rectangular opening on piece B. The openings on both pieces should line up.

3. Flip piece B back over, and insert the square end of piece J through the center rectangular slit on piece B from the back. Then insert it through this bottom slit.

4. Flip piece B back over once again. Glue the wide base of the pull tab (J) to the bottom of piece C, as indicated in the illustration.

5. Glue the small triangle at the top of piece D to the corresponding shaded triangle on piece E. Flip the pieces, and glue the stem closed by gluing the rounded side of piece E underneath the more rectangular side. The pull tab is now inside the stem.

6. Glue the small tab at the top of piece E to the underside of the goblet base (B).

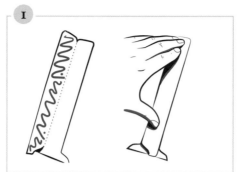

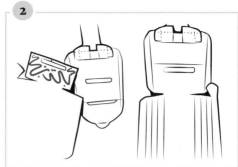

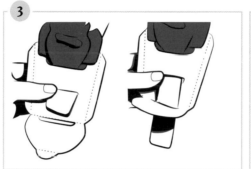

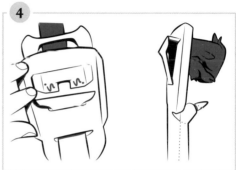

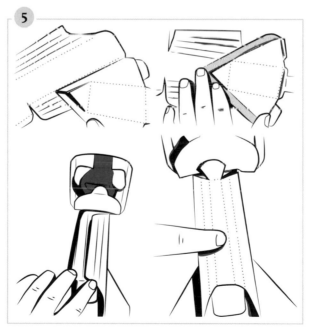

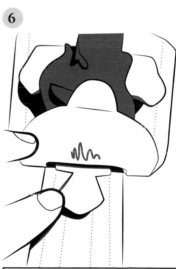

> **NOTE:** Gluing the triangular wedge piece down is easiest when the piece is flat, so do it before assembling the rest of the stem.

ASSEMBLING THE BASE

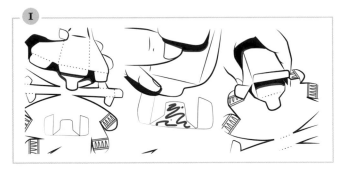

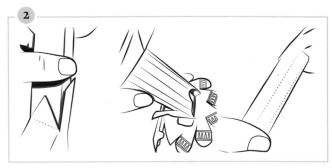

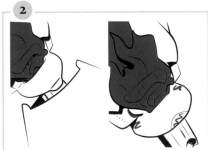

1. Glue the small tab on piece E to the corresponding shaded area on piece I. Glue the 3 tabs on piece D into place on piece I using the gray-shaded areas as guides.

2. Glue the long tabs of piece D to the sides of the stem piece (E).

3. Create the base piece (I) by folding along the score lines and gluing the tabs shut, using the gray-shaded areas as guides.

ASSEMBLING THE GOBLET

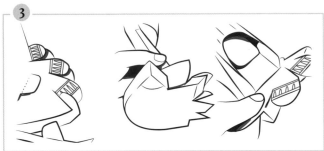

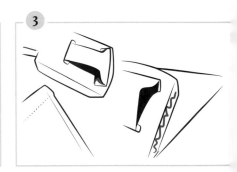

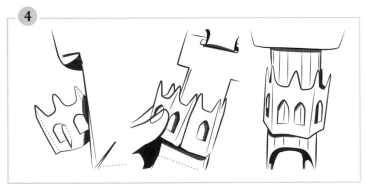

1. If using, glue the extra brim piece you created into place at the top of piece K.

2. Glue the 3 small tabs on the goblet piece (K) to the corresponding shaded areas on the rounded side of piece B, using the gray-shaded areas as guides.

3. Glue the sides of the goblet (K) into place on the side tabs of piece B.

4. Glue the decorative stem piece (F) to piece E, using the gray-shaded areas as guides.

Behind the Magic

The runes written on the goblet's rim are based on Elder Futhark, one of several runic alphabets that date back to the second century.

ABOVE: In the Great Hall of Hogwarts, Headmaster Albus Dumbledore (Michael Gambon) reveals the Goblet of Fire to captivated students in *Harry Potter and the Goblet of Fire*.

"I'D LIKE TO SAY A FEW WORDS: ETERNAL GLORY. THAT IS WHAT AWAITS THE STUDENT WHO WINS THE TRIWIZARD TOURNAMENT"

Albus Dumbledore, *Harry Potter and the Goblet of Fire*

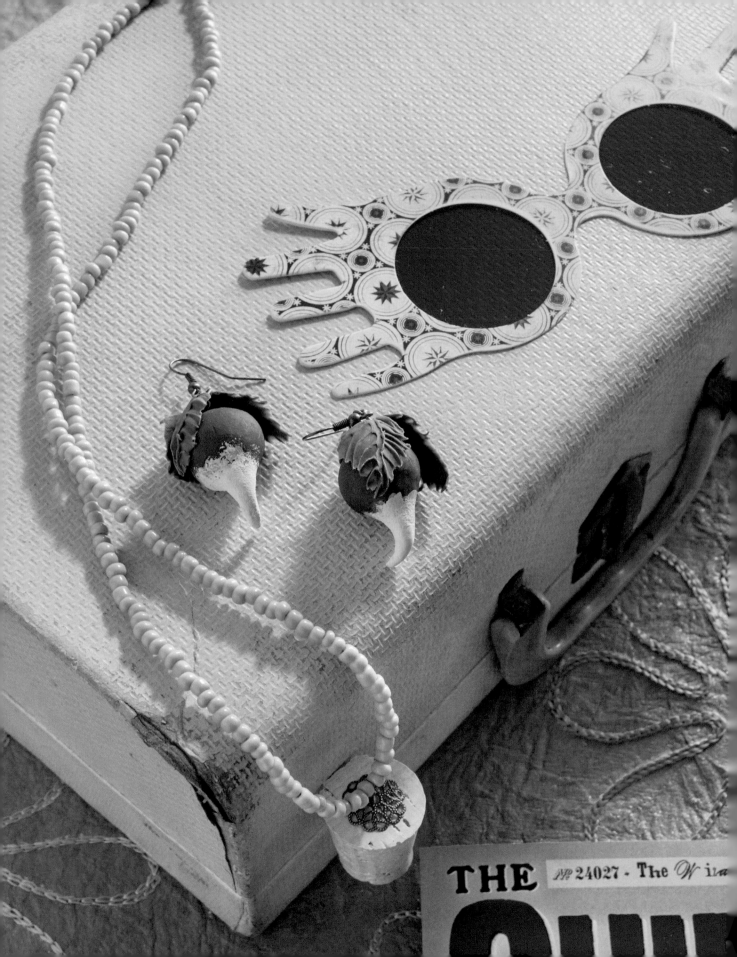

THE

№ 24027 - The *Wil*

Luna Lovegood's Butterbeer Cork Necklace and Dirigible Plum Earrings

Designed by **HEATHER VAN DOORN**

SKILL LEVEL ⚡⚡⚡

Upon arrival at Hogwarts in *Harry Potter and the Order of the Phoenix*, Harry sees for the first time that the carts that take the students up to the castle are being pulled by skeletal winged creatures. His friends have no idea what he's talking about. Then the lilting voice of Luna Lovegood calls out: "You're not going mad. I can see them, too." Once introduced, Hermione comments on Luna's unique necklace—a double loop of blue beads with a Butterbeer cork as its pendant. Luna, played by actress Evanna Lynch, wears the necklace for protection from Nargles, inexplicable magical creatures that can cause trouble, if you believe in them. Luna does, and doesn't worry what other people think about that. The Ravenclaw also wears a pair of radish-shaped earrings, actually modeled on Dirigible Plums. When she was presented by the costume designer with a pair of these created in radish red, Lynch was quick to point out they were supposed to be orange, and then remade the jewelry in the correct color herself to wear instead.

Luna joins her friends in Dumbledore's Army, to fight against the Dark Lord Voldemort. During their final battle, in *Harry Potter and the Deathly Hallows – Part 2*, the beaded chain of the Butterbeer cork necklace is seen again around her neck, a trademark talisman that, hopefully, has kept the Nargles at bay through the years.

WHAT YOU NEED:

FOR THE CORK NECKLACE

- 2 crimp tubes
- 26-inch length of .015-inch bead-stringing wire
- 1 clasp
- Crimping pliers
- Turquoise 6mm glass beads
- 24 gauge (about 0.5mm) jewelry wire
- Wire cutters (or nail clippers)
- Hand drill and small drill bit (about 0.6mm)
- Cork bottle stopper
- 2 decorative jewelry caps (1 large, 1 small)
- Roundnose pliers

FOR THE DIRIBLE PLUM EARRINGS

- 2-ounce package orange polymer clay
- 24 gauge (about 0.5mm) jewelry wire
- Wire cutters (or nail clippers)
- Liquid clay
- Oven mitts
- 2-ounce package green polymer clay
- Roundnose pliers
- 2 jump rings
- Drop-earring backs
- White acrylic paint

MAKING THE CORK NECKLACE

1. Place a crimp tube on the bead-stringing wire and, using the last inch of the wire, loop the wire through one side of the clasp and back through the crimp tube.

2. Use the crimping pliers to clamp down on the crimp tube as close as you can get it to the clasp. This will secure the wire.

3. String the turquoise beads until there is only 1 inch of wire left.

4. String on another crimp tube and loop the remaining wire through the other side of the clasp and then through the crimp tube.

5. Pull the tail of wire tight as much as possible, and crimp with the crimping pliers.

6. Cut a length of jewelry wire longer than the length of the cork.

7. Using the drill and small bit, drill lengthwise through the center of the cork.

8. Thread the wire through the cork and make a U-shape loop on the other side using the roundnose pliers.

9. Pull the wire through the small decorative cap, and push flush with the bottom of the cork.

10. Pull the other end of wire through the larger decorative cap, and using the roundnose pliers, loop the wire back through the cap and push it into the cork, leaving a small loop to attach to the necklace.

11. Using the roundnose pliers, make a small S hook out of the jewelry wire.

12. Attach one side of the hook to the top of the cork. Hook the other side of the S hook to the center of the necklace.

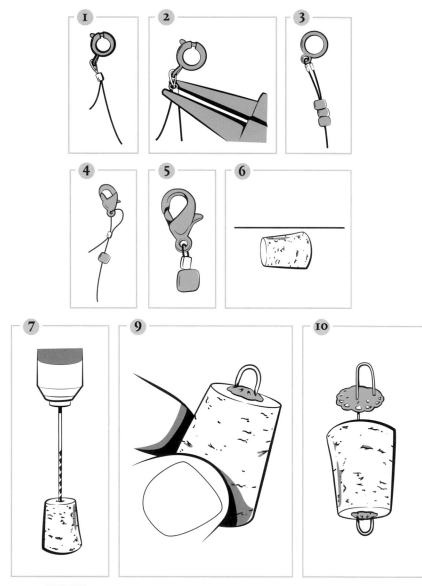

MAKING THE DIRIGIBLE PLUM EARRINGS

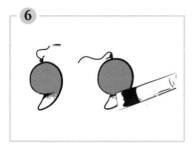

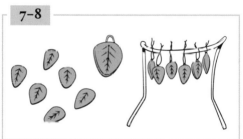

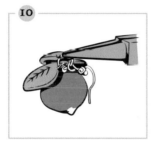

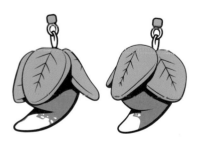

1. Roll 2 balls of orange clay approximately ¾ inch in diameter.

2. Taper one end of each ball into a point, making a teardrop shape. Curve the tapered end just slightly to make it look more like a plum.

3. Cut two ½-inch lengths of wire, and put a loop on one end of each by using roundnose pliers. Add a drop of liquid clay to the unlooped end and gently push it into the top of each plum.

4. You'll need a hanger for baking your sculpted pieces, so they won't warp or lose their shape while heating up. To create your hanger, bend about 8 inches of wire into a freestanding "swing set," as shown.

5. Hang the 2 plums on the hanger using extra bits of wire, and bake according to the clay package's instructions. Remove from hanger when cool.

6. Stipple a little white paint on the bottom of each plum. Let dry.

7. Next, sculpt 6 leaves out of green clay. Make the leaves at least ⅛ inch thick at their base.

8. Using roundnose pliers, make 6 small (about ¼ inch) U shapes out of wire.

9. Insert the U-shaped wires into the base of the leaves so that each leaf has a loop. Hang them on the baking hanger and bake. Make sure none of the leaves are touching each other.

10. Open a jump ring using the roundnose pliers, and place one plum, three leaves, and a drop-earring back. Close up the ring. If the plum and leaves don't hang right, open the jump ring again and adjust.

11. Repeat with the other earring.

—☆—

"WHAT AN INTERESTING NECKLACE."
"IT'S A CHARM, ACTUALLY. KEEPS AWAY THE
NARGLES."

Hermione Granger and Luna Lovegood,
Harry Potter and the Order of the Phoenix

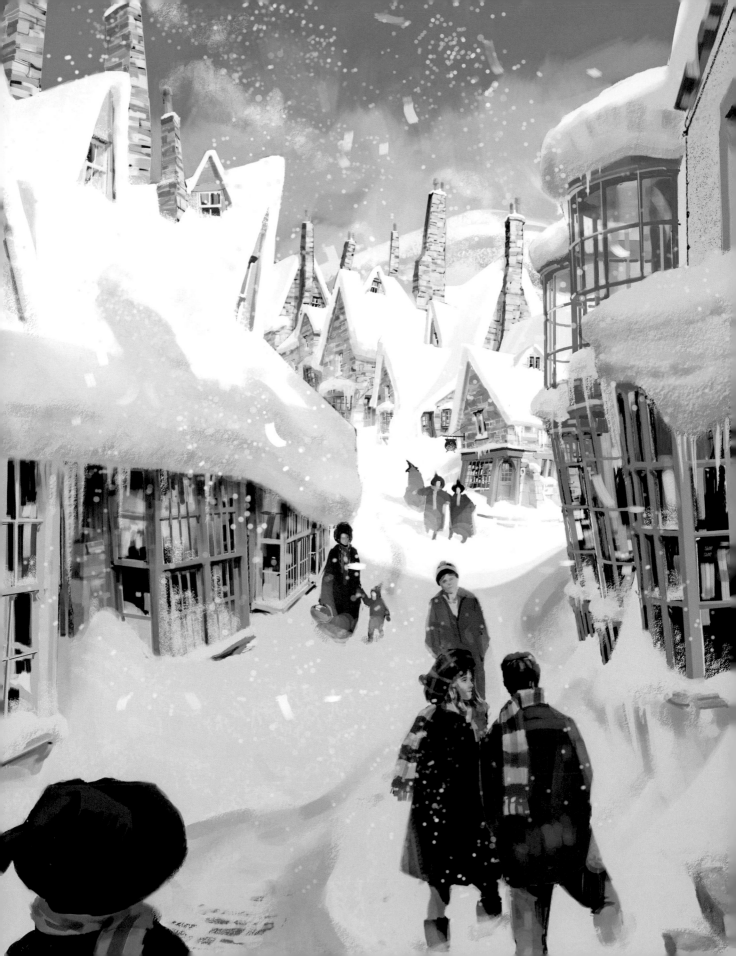

CHAPTER 4:
HOLIDAYS AT HOGWARTS

"I'VE GOT PRESENTS?"

Harry Potter, *Harry Potter and the Sorcerer's Stone*

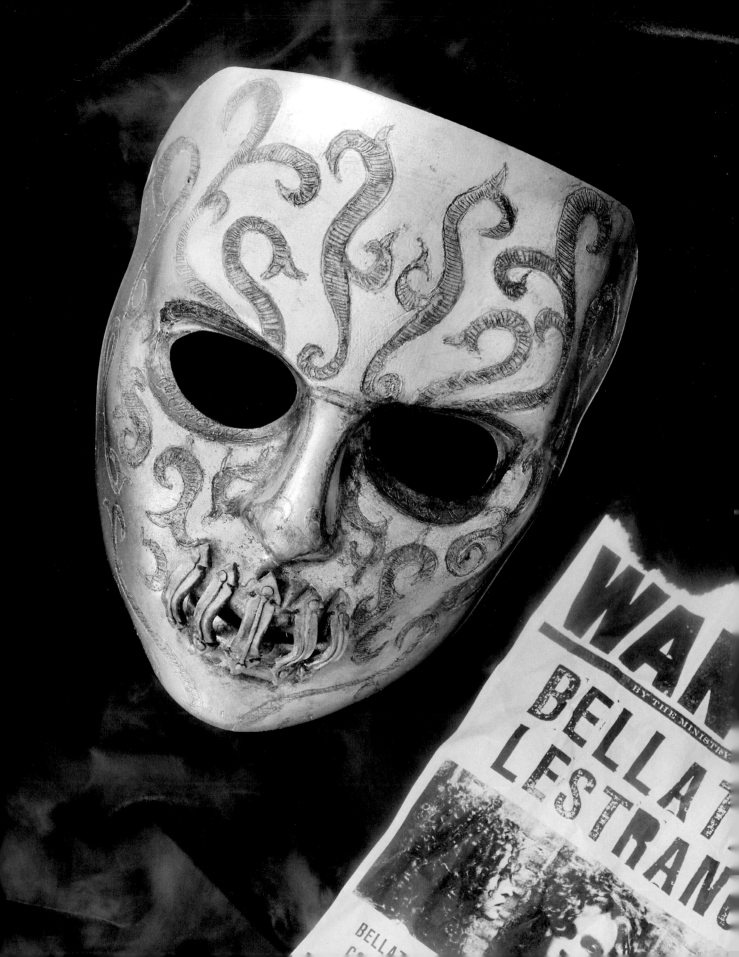

BELLATRIX LESTRANGE'S DEATH EATER MASK

Designed by **HEATHER VAN DOORN**

SKILL LEVEL ⚡⚡⚡⚡⚡

Halloween in the Muggle world is a holiday where masks are worn to scare away ghastly ghouls and grim ghosts. So, what better mask to wear for frights than that of a Death Eater? These menacing acolytes of Voldemort surface from years in hiding in *Harry Potter and the Goblet of Fire*, where their skull-shaped half-masks were digital creations. For *Harry Potter and the Order of the Phoenix*, the filmmakers wanted to raise the Death Eaters' creepy factor. Full-face masks were created with a uniform silhouette, but each mask was given a unique design or motif so the character underneath could be personally identified. Ornamentation includes complex tracery inspired by sixteenth- and seventeenth-century Moghul arabesque patterns. Slitted eyes and barred mouths evoke medieval torture devices. Each mask was molded to the actor's face, after which the creature effects department sculpted the designs, then handed them off to the prop team to finish with delicate copper work. "We made them using processes that the Greenwich armory would use," says prop modeler Pierre Bohanna, referring to the royal workshops at Greenwich that supplied armor to Henry VIII. The final touch was electroplating each mask in silver. "Silver has a quality you just can't replicate [on-screen] with paint," he adds. The ten closest lieutenants of Voldemort, including Bellatrix Lestrange, whose mask is re-created here, wore the most elaborate designs, which were more an indicator of wealth than of rank.

WHAT YOU NEED:

- Blank plastic face mask
- Primer spray paint
- Tracing paper
- Templates (page 139)
- Pencil
- Woodburning tool (ideally with changeable tips, but a standard chisel tip will work)
- Fine-grit sandpaper
- Silver spray paint
- Silver polymer clay
- Clay cutting tool
- Pen
- Aluminum foil
- Baking sheet
- Oven mitts
- E6000 glue
- Acrylic paint in dark brown, gold, light gray, and black
- Small and medium paintbrushes
- Small sponge or makeup applicator
- Gloss medium (spray or brush type)

OPTIONAL

- Transfer paper

1. Spray-paint your mask with primer, and let dry completely.

2. Lay tracing paper over the template (page 139) and trace with a pencil.

3. Turn the tracing paper over and trace the back. (Note: You can also use transfer paper.) Lay out the paper over the mask. You may need to cut it into pieces for it to lie flat. Then, use a stylus or pencil to go over the design to transfer to the mask.

4. In a well-ventilated area, take your woodburning tool and carefully follow the traced design to burn into the plastic mask. Avoid holding the tool in one place for too long, or you will burn through the plastic.

5. Remove any burrs left in the burned grooves with fine-grit sandpaper, and spray-paint the mask silver. Let dry.

6. Roll out a sheet of silver clay, about 1/16 inch thick.

7. Use the template to trace and cut out 5 clamps from the sheet of silver clay.

8. Roll 10 tiny balls from silver clay. Place one ball on each end of each clamp, in the middle of the arrow shapes. Gently push on each ball to flatten slightly.

9. Make 5 thin snakes and lay one down the center of each clamp. Press gently into place.

10. Lay the clamps over a cylindrical object like a pen to create a rounded shape. Gently squeeze the side edges in to get a rolled-edge look.

11. Place a small piece of aluminum foil over the mouth of the mask. Place each clamp on the mask onto the foil over the mouth. Carefully remove the foil with the clamp pieces still on, and bake on a baking sheet according to the clay package's instructions. The foil will hold the shape of clamps to the mouth while baking.

12. When cool, glue the clamps to the mask with the E6000 glue. Let dry.

13. Mix dark brown paint with a dab of gold and dilute with water to make a wash. Brush over the mask, paying special attention to the grooves. You can use a makeup sponge to push the paint further into the grooves.

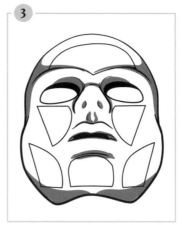

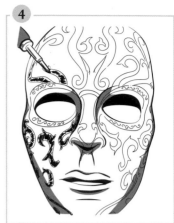

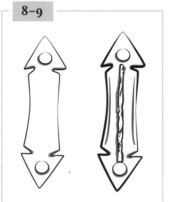

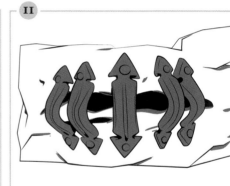

14. Slowly build up the paint, adding more dark brown paint to vary the look, until you're happy with the look.

15. Blend a little black and gray and dilute with water to create another wash. Use this to brush under the eyes and add a little depth to the engraved design. Remember to start slow as you can always add more paint as you go.

16. When you arc satisfied with the look of your Death Eater Mask and the paint is dry, cover the mask with a coat of gloss medium.

Clamp Template

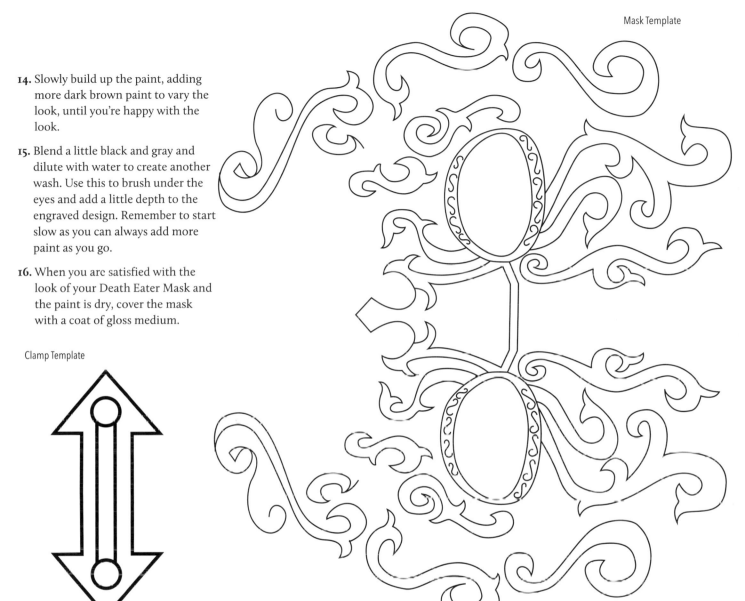

"I ASSURE YOU, MY LORD, I HAVE NEVER RENOUNCED THE OLD WAYS. THE FACE I HAVE BEEN OBLIGED TO PRESENT EACH DAY SINCE YOUR ABSENCE . . . THAT IS MY TRUE MASK."

Lucius Malfoy, *Harry Potter and the Goblet of Fire*

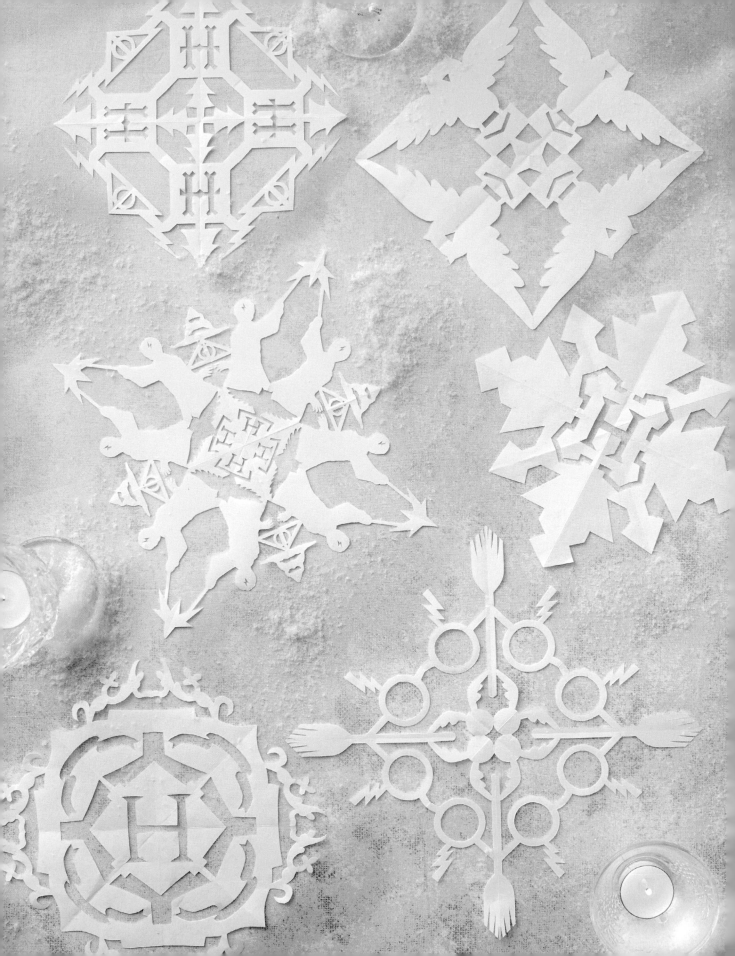

Harry Potter Snowflakes

Designed by **JILL TURNEY**

SKILL LEVEL ⚡

During the holiday season at Hogwarts, snow not only blankets the ground around the castle but falls from the ceiling of the Great Hall, as seen in *Harry Potter and the Sorcerer's Stone* and *Harry Potter and the Chamber of Secrets*. The bewitched ceiling often showcases the weather conditions above it, but fortunately, the digital artists created a horizon line in the room, so that the snowflakes fade away at a level far above the students and professors.

Snowflakes decorate the invitation for the Yule Ball in *Harry Potter and the Goblet of Fire*, and again fall as the Triwizard Tournament champions arrive at the Great Hall for the festivities. In *Harry Potter and the Half-Blood Prince*, however, it is Ron Weasley who causes snow to fall by waving his wand around haphazardly as Hermione and Harry inform him how he broke up with Lavender Brown. Those flakes descended via a practical effect. Using intricate motifs and iconic symbols from Harry Potter's story in their design, these snowflakes will bring wintry wizarding fun to your own Great Hall.

WHAT YOU NEED:
- White letter-size printer paper (20 pounds or lighter weight)
- Burnisher (if you don't have one, the back of a spoon will work)
- Cutting mat
- Ruler or straight cutting edge
- Craft knife with sharp point
- Tape
- Tracing paper
- Dark lead pencil (No. 2 pencil will work)
- Ballpoint pen
- Small scissors

Snowflake 1
This snowflake comprises Harry Potter's lightning-bolt scar, the symbol for the Deathly Hallows (three items that make one the master of death), and the *H* of Hogwarts School of Witchcraft and Wizardry. There are also eight Christmas trees, the same number that line the Great Hall during the holidays.

Snowflake 2
This snowflake offers a more graphic take on holiday trees and the Hogwarts *H*.

Snowflake 3
This snowflake was inspired by the Hogwarts crest, which was devised by the films' graphic designers. In the center is the Hogwarts *H*, framed by garlands of ribbon and surrounded by a decorative border.

Snowflake 4
Four owls, each holding an envelope—perhaps your invitation to Hogwarts?—make up the borders of this snowflake inspired by the owl post, a service in the wizarding world that delivers letters and packages. The spaces between the owls' wings represent Christmas trees.

Snowflake 5
Quidditch is the wizarding world's favorite sport, played while flying on broomsticks, which create the corners of this snowflake. In the center are Golden Snitches. Catch one of these, and you receive 150 points—enough to win the game! Gryffindor Seeker Harry Potter's glasses and scar fill out the rest of the snowflake design.

Snowflake 6
This snowflake is jam-packed with Harry Potter imagery—the Sorting Hat, which declares each student's Hogwarts house at the beginning of their first year; the Deathly Hallows symbol; owls carrying envelopes with Harry's initial on them; and even Harry Potter himself, with his lightning-bolt scar, casting a spell with his wand.

FORMING 8-SEGMENT TRIANGLE

1–2

3

1. Place a piece of printer paper on a hard flat surface.

2. Fold the top left corner down so the top edge of the paper aligns with the right edge.

3. Use your burnisher to press the fold flat.

4. Transfer your folded paper to a cutting mat. Using a ruler and craft knife, trim the extra paper that extends beyond your folded paper. Recycle the trimmed paper; you won't need it anymore.

5. Fold the upper right corner of the triangle down to meet the lower left corner.

6. Burnish the fold flat.

7. Fold the triangle in half again to form a smaller triangle, and burnish the fold.

You now have a basic 8-segmented triangle, which can be used for any of the snowflakes you choose to make.

4

End up like this.

5

End up like this.

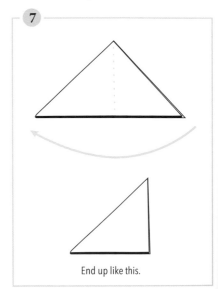

7

End up like this.

TRANSFERRING SNOWFLAKE DESIGNS

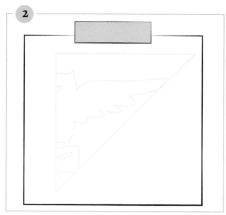

1. Choose the snowflake you would like to make. Find its corresponding template on pages 145–146.

2. Tape a piece of tracing paper over the template.

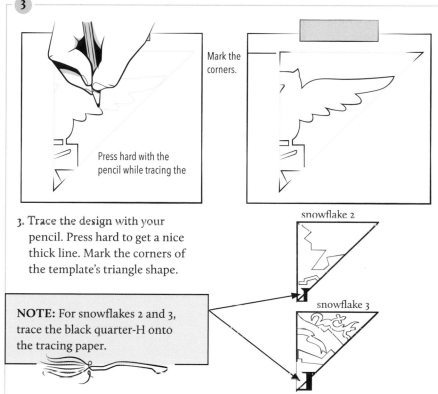

Mark the corners.

Press hard with the pencil while tracing the

snowflake 2

snowflake 3

3. Trace the design with your pencil. Press hard to get a nice thick line. Mark the corners of the template's triangle shape.

> **NOTE:** For snowflakes 2 and 3, trace the black quarter-H onto the tracing paper.

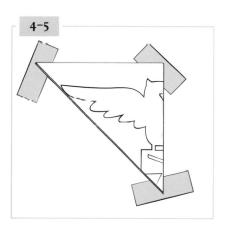

4. Place your tracing pencil-side-up onto your flat surface. Align your folded triangle on the tracing's marked corners. Make sure the bottom corner of the template is aligned on the triangle corner that has all the paper edges folded in. Tape in place.

5. Flip the tracing and triangle over so the tracing paper is on top.

6. Trace over the pencil lines with a ballpoint pen to transfer the design to the folded triangle. Important! For snowflakes 2 and 3, don't trace the quarter-*H* at this stage!

7. Once the design is all transferred, remove the tape and tracing paper from the folded triangle. You're now ready to cut your design!

CUTTING THE SNOWFLAKE

Cut along the lines through all 8 layers of the folded triangle. Snowflakes 2, 3, and 4 can be cut with small scissors. Snowflakes 1, 5, and 6 are a little more complicated and require a craft knife to cut through all the layers.

KNIFE CUTTING TIPS:
- **Make sure your craft knife has a sharp blade tip.**
- **Cut out the small areas first.**
- **Cut a few layers at a time.**
- **In the tight corners and curves, poke your knife up and down through the paper layers until all 8 layers are cut through.**

MIDDLE *H* CUTS FOR SNOWFLAKES 2 AND 3

1. After cutting your 8-segment design for snowflakes 2 and 3, unfold the 8 segments, and flatten out as best you can.

2. Fold the snowflake in half along the vertical center.

3. Fold it along the horizontal center.

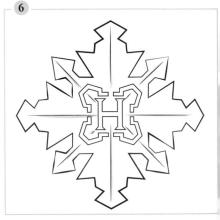

4. Lay the tracing with the quarter-*H* over the newly folded snowflake. Transfer the design as you did before with the ballpoint pen.

5. Remove the tracing paper. Cut the shape out of the 4 layers of paper.

6. Unfold the snowflake to reveal the *H*.

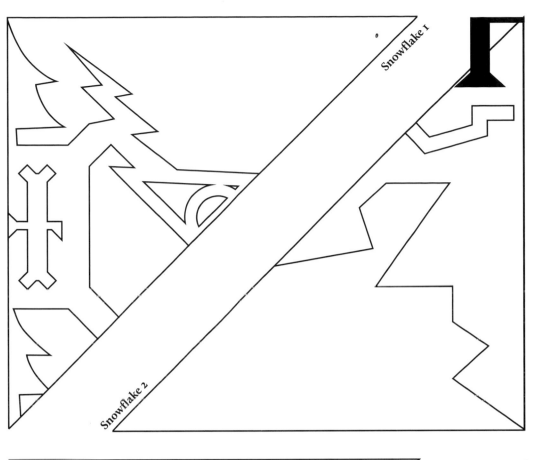

Snowflake 1

Snowflake 2

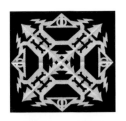

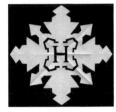

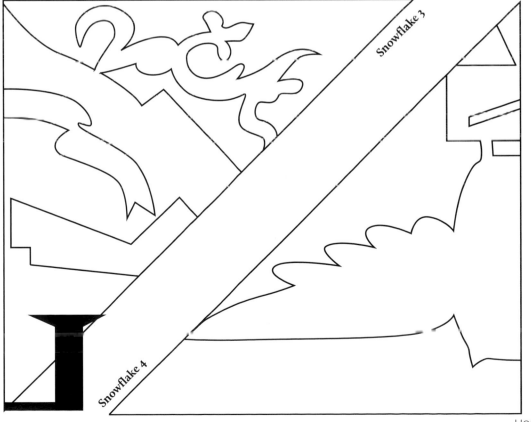

Snowflake 3

Snowflake 4

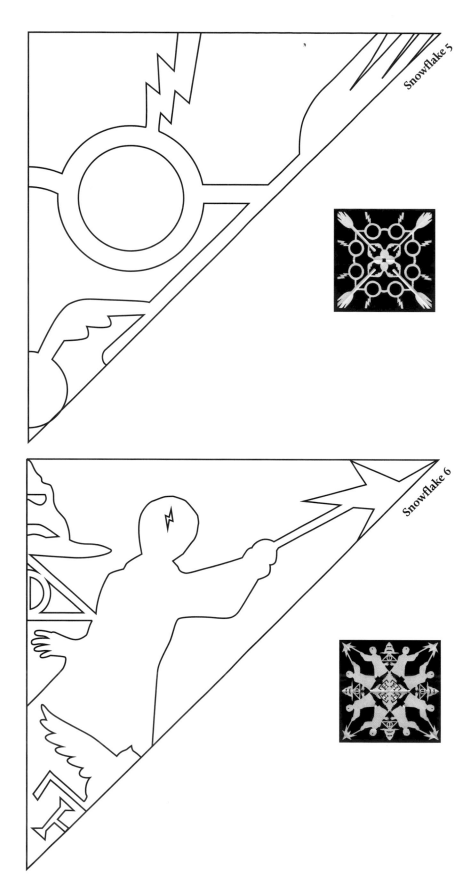

Snowflake 5

Snowflake 6

"STOP IT, RON. YOU'RE MAKING IT SNOW."

Hermione Granger, *Harry Potter and the Half-Blood Prince*

BEHIND THE MAGIC

The snow seen outside Hogwarts and Hogsmeade was created by using dendritic salt, which clumps like real snow. It even squeaks like freshly fallen snow when walked upon.

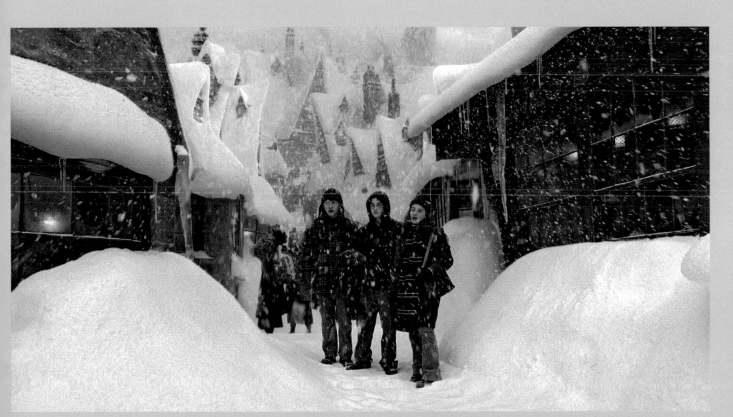

ABOVE: Ron Weasley (Rupert Grint), Harry Potter (Daniel Radcliffe), and Hermione Granger (Emma Watson) visit Hogsmeade for the first time in *Harry Potter and the Prisoner of Azkaban.* This wizarding village sits above the snow line, so it always looks like a Christmas card.

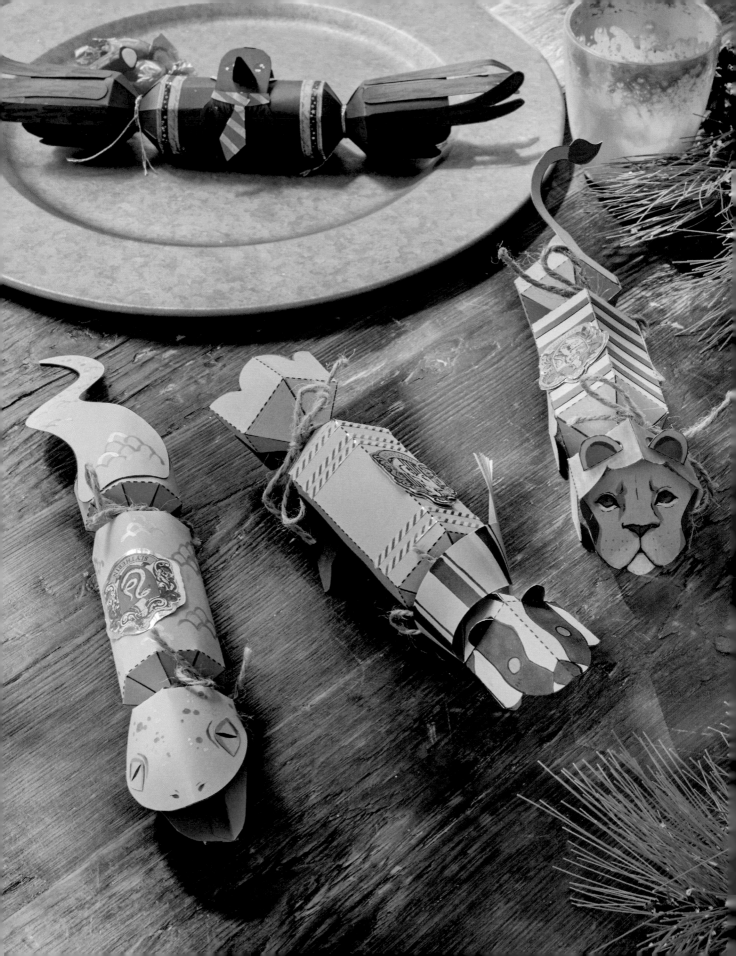

House-Themed Christmas Crackers

Designed by **MATTHEW REINHART**

SKILL LEVEL ⚡⚡

Christmas crackers are a British tradition and part of every wizard's holiday celebration. Created in the mid-1800s to wrap sweets in a twist of paper, Christmas crackers evolved to hold prizes including a paper crown, slips of paper featuring jokes or trivia, or a small novelty toy. Two people grab the ends of the cracker and pull, breaking it open to reveal the treasure hidden inside the middle segment. Christmas crackers are present at every holiday in the Harry Potter films. They're used as tree decorations in *Harry Potter and the Sorcerer's Stone* and *Harry Potter and the Half-Blood Prince*, and strewn on Great Hall tables in *Harry Potter and the Chamber of Secrets*. In *Harry Potter and the Order of the Phoenix*, Harry celebrates Christmas at number twelve, Grimmauld Place, where the crackers on the table are a dark purple. The year Harry spends the holiday at The Burrow in *Half-Blood Prince*, Fred and George Weasley pull open a Christmas cracker with a spring inside.

As the custom of Christmas crackers took hold, manufacturers began designing them with themes. These crackers pay tribute to the four house mascots of Hogwarts: a snake for Slytherin, badger for Hufflepuff, lion for Gryffindor, and eagle for Ravenclaw. Before closing the middle segment, in addition to the house-colored crown, you can add stickers of house crests or scraps of paper bearing quotes from the Harry Potter movies.

WHAT YOU NEED:

- Christmas cracker templates (pages 183–189)
- Colored cardstock, preferably green, brown, light grey, and yellow
- Ruler
- Tissue paper
- Markers or crayons
- Glue
- Cutting tool, such as a utility knife or scissors
- Twine (can substitute yarn or ribbon)

OPTIONAL:

- Decorative tape

PREPPING THE TEMPLATES

1. Punch out all cracker templates on pages 183 **to** 189.

2. Fold the template pieces on all the creased lines. Press firmly to make crisp folds.

3. Repeat for all template pieces.

1–3

DECORATING

It's best to do most of the coloring and decoration before assembly, when the pieces are flat. Additional embellishments can be added later, but coloring as well as small details and hand-drawn designs should be done first.

ADDING EMBELLISHMENTS & DETAILS

Get creative! Make your crackers unique, adding as much or as little detail as you want. Some ideas: metallic accents like metallic paper, decorative tape, or markers; props (give your crackers house scarves or ties to wear); or patterns, such as lines, dots, or geometric shapes made from paper or cardstock and adhered to the crackers or drawn by hand.

MAKING A PAPER CROWN

1. Cut tissue paper 4 to 5 inches tall and long enough to wrap around your head.

2. Glue ends together to form a circle.

3. Fold the tissue paper in half several times until paper is 2 to 3 inches wide.

4. Cut a diagonal line along top of folded tissue paper.

5. Unfold to reveal crown.

NOTE: Other prizes can include candy, small toys, or even surprise notes.

4

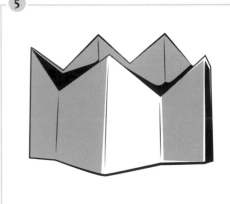

5

ASSEMBLING THE HUFFLEPUFF CRACKER

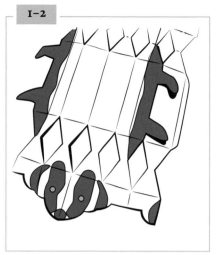

1-2

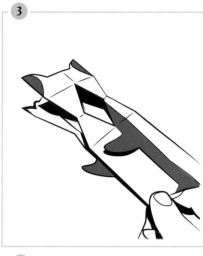

3

1. Color the badger's face as seen here onto the centermost curved pieces of piece C. Color the leg pieces black.

2. Glue piece D to the corresponding gray-shaded area on the left side of piece C. Glue piece E to the corresponding gray-shaded area on the right side of piece C.

3. Fold along each of the score lines.

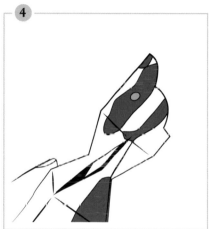

4

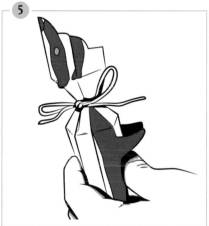

5

6

4. Glue the gray shaded area on the top right of piece C to the top left of the same piece to give the cracker shape. Also glue the small tab on the inside of the body.

5. Use approximately 10 inches of twine to cinch one end of the tube closed at one of the cut diamond parts of the tube. Be careful not to pull too tightly or it can rip the paper.

6. Insert prizes into the open end, making sure not to overfill.

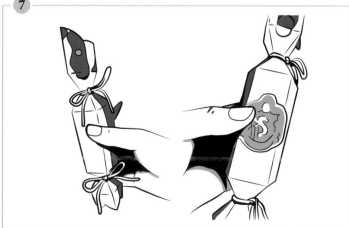

7

7. With another 10-inch piece of twine, cinch the other end closed at the other cut diamond part of the tube. Pull twine tight enough to keep prizes from falling out, but not tight enough to tear the paper.

NOTE: The side of piece C with the badger's head has pieces that overlap, so there are only 4 facets on that end instead of 5. The overlap is not obvious once the end of the cracker is cinched with string.

ASSEMBLING THE GRYFFINDOR CRACKER

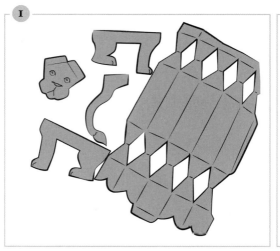

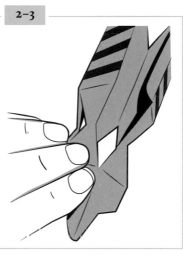

1. Color a face on piece G.

2. Fold along all score lines to give the cracker shape.

3. Glue the three slim shaded tabs on piece F under the other side of the cracker. This will ensure the cracker keeps its shape.

4. Do not cinch closed the ends of piece F.

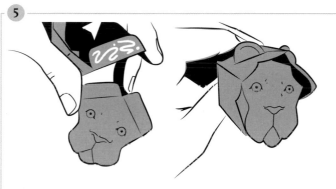

5. Add glue to the tab on the top of the body (F), and adhere the bottom of the face (G) here.

NOTE: When gluing the head tab, be sure not to glue the ears down. The tabs on the top of the lion's head aren't glued, just inserted into the opening to stabilize the piece. The head is only attached by the bottom tab under the chin.

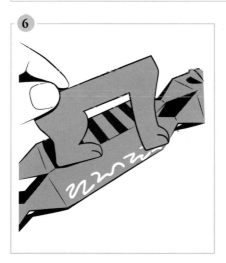

6. Glue pieces J and H onto the corresponding gray-shaded areas on the sides of piece F.

7. Glue the tail piece (Q) onto the corresponding gray-shaded area on the bottom of piece F.

8. Now cinch closed the top side of piece F with a 10-inch piece of twine. Add the prizes to the open end, and cinch closed with another 10-inch piece of twine.

ASSEMBLING THE CRACKERS (SLYTHERIN AND RAVENCLAW)

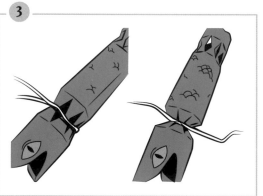

1. Gently wrap the cracker paper (A or K) around something (like a glue bottle) to curve it

2. Glue each corresponding tab on pieces A and C to create the cracker shape, being careful not to crease the tube shape. There are three shaded tabs on each cracker body that will need to be glued under the other side so that the cracker keeps its shape.

3. Use approximately 10 inches of twine to cinch one end of the tube closed at one of the cut diamond parts of the tube.

4. Insert prizes into the open end, making sure not to overfill.

5. With another 10-inch piece of twine, cinch the other end closed at the other cut diamond part of the tube. Pull twine tight enough to keep prizes from falling out, but not tight enough to tear the paper.

ASSEMBLING SLYTHERIN CRACKER (CONTINUED)

1. Curve tail piece (B) around a bottle to curve the paper.

2. Glue tail piece (B) to the cracker (piece A).

ASSEMBLING THE RAVENCLAW CRACKER (CONTINUED)

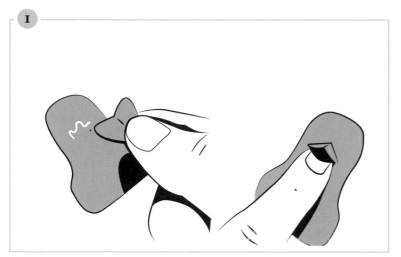

1. Glue the beak (L) to the head piece (P), lining up the tabs on piece L with the corresponding gray areas as a guide.

2. Glue the 3 feathers from piece N onto the corresponding shaded areas on the top left side of piece K. Do the same with the feathers from piece O onto the corresponding shaded areas on the top right side of piece K.

3. Repeat Assembling Crackers steps 1 through 5.

4. Gently curve the tail piece (M) around a glue bottle to curve the paper. Glue piece M onto piece K at the corresponding larger shaded rectangle at the center.

5. Gently curve the head piece (P) around a glue bottle to curve the paper. Glue piece P to the corresponding smaller shaded rectangle at the center of piece K.

BEHIND THE MAGIC

When the Great Hall was decorated all in silver for the Yule Ball in *Harry Potter and the Goblet of Fire*, each crystal-themed place setting on the round tables featured a silver Christmas cracker.

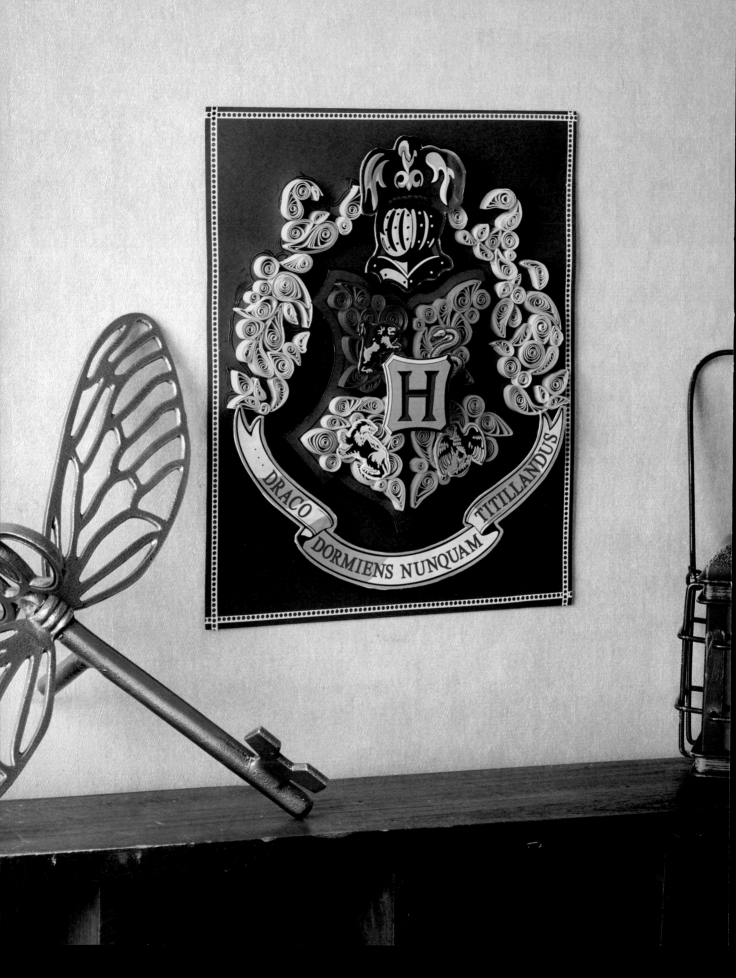

Quilled Hogwarts Crest Christmas Card

Designed by **MATTHEW REINHART**

SKILL LEVEL ⚡⚡⚡

WHAT YOU NEED:
- Crest templates and graphics (page 191)
- Cutting tool
- Colored cardstock, such as green, blue, red, yellow, and black
- Quilling tool (see below)
- Glue
- Tweezers
- Ruler
- Tracing paper

Christmas at Hogwarts School of Witchcraft and Wizardry is replete with Christmas cards. They're strung up in the Gryffindor boys' dormitory in *Harry Potter and the Sorcerer's Stone* and displayed on sideboard shelves in the kitchen of number twelve, Grimmauld Place in *Harry Potter and the Order of the Phoenix*, where Harry celebrates the holiday with the Weasleys, Hermione, and his godfather, Sirius Black.

Quilling paper decorations have been around since paper was invented, circa 200 BC in China. Quilling was used to ornament books during the Renaissance—using strips of paper trimmed from illuminated manuscripts—and became a popular craft for European ladies of leisure and American colonists in the 18th century. Today, quilling has had its own renaissance and has even been elevated to a fine art.

Heraldic crests always include a shield with its colors and elements, bordered by supporting animals and a helmet or crown. The mascot for each house is displayed on the Hogwarts crest: a lion for Gryffindor, a badger for Hufflepuff, an eagle for Ravenclaw, and a snake for Slytherin. Cradling the crest is the school motto, "*Draco dormiens nunquam titillandus*," which translates to "Never tickle a sleeping dragon!" What better way to send Christmas wishes to friends and family than with a card embellished with quilled paper in the form of the Hogwarts crest to celebrate your Hogwarts pride.

Quilling can be done by hand, but a tool is easier. You can purchase a quilling tool online or at a craft store, or create a DIY one by attaching a thin-tipped item (such as a paper clip, toothpick, sewing needle, or cotton swab) to a stick or dowel.

NOTE: The thinner the tool, the tighter the paper coils will be.

1. Punch out the provided Shield and Filigree templates for the crest (page 191).

2. Measure out and cut ¼-inch-wide strips in each of the four house colors. You will need 5-inch-, 7-inch-, and 9-inch-long strips. Six to seven of each size, in each color, are recommended for the house crest quadrants.

3. Additionally, cut 14 strips of black paper (9 inches long by ¼ inch wide), and roll tightly to create peg lifts for later assembly. You will also need one black coil from a strip of paper that is ½ inch wide.

HOW TO QUILL

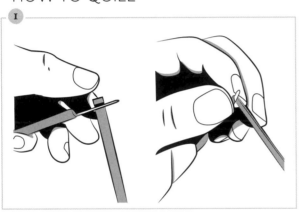

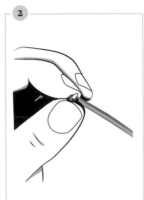

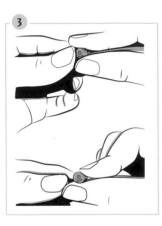

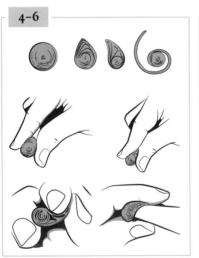

1. Hold the tool in one hand, and use the other hand to wrap one end of the paper strip over the tool.

2. Gently pinch the paper between 2 fingers and tightly roll it to start the coil. If you're having trouble, lightly wet the end of the paper with water to help it hold better.

3. Continue tightly rolling the paper until you've wrapped the entire length of the strip. If the tool is uncomfortable to hold, you can remove the coil and roll the rest using your fingers. A simple rolling motion between 2 fingers is the best way to get a tight curl.

4. At the end of the paper strip, release the coil to let the layers loosen. Secure the end of the strip with a small dab of glue.

5. Pinch one end of a coil to create a teardrop shape.

6. Wrap one end of a teardrop shape around your finger or a pen to create a pinched teardrop.

7. Use tweezers to hold small pieces more tightly.

8. If desired, cut down paper strips, or glue 2 strips together to make smaller or bigger coils.

ASSEMBLING THE CREST

1. Create different coils as desired.

2. Arrange pieces for each section on the crest piece before gluing.

3. Glue each piece down, pressing firmly.

4. Repeat process. Fill in each quadrant with respective colors.

5. Repeat steps for Filigree pieces, using the template as a guide. Feel free to follow this template as loosely or as closely as desired. This is your chance to experiment with different shapes and designs.

6. Punch out provided crest graphics, and gather all your pieces.

7. Glue the ½-inch black peg to the center of the shield. Glue each house animal to its respective color (Gryffindor lion: red; Hufflepuff badger: yellow; Ravenclaw eagle: blue; Slytherin snake: green).

8. Create a base page to support your quilled pieces by tracing the template on page 160 and copying to your black cardstock. Glue the 14 black lifting pegs to the base page.

9. After attaching all lifting pegs to the base page, apply glue to the tops of each lifting peg and begin final assembly.

10. Glue the Shield, Knight's Helmet, and Banner to their respective pegs. The Banner goes on the 5 bottommost pegs that form a V. The Knight's Helmet goes on the top 3 vertical pegs. The Shield goes on the remaining 6 central pegs. Glue the Filigree pieces directly to the base page on the top left and right sides of the Shield (no lifting pegs).

11. Glue H graphic to the ½-inch center peg.

12. Decorative paper can be added behind the base page to frame the final piece. Another option is to use decorative tape, yarn, or string to frame the base page.

13. The final piece has 3 different heights of layers: the Filigree glued directly on the page, the Shield, Banner, and Knight's Helmet ¼ inch higher, and the H another ¼ inch above that.

BEHIND THE MAGIC

The Hogwarts crest, and the crests for Beauxbatons Academy of Magic and the Durmstrang Institute, were designed by graphic artists Miraphora Mina and Eduardo Lima.

Center Weight
Template (C)

Wing 1 (E)

Top Body (D)

9 6

10 7

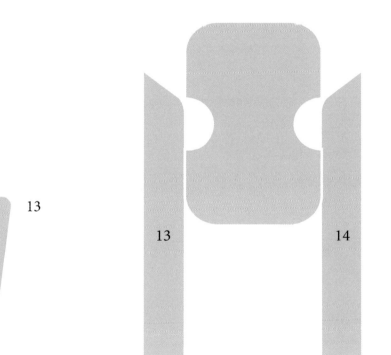

15 16

4 13

13 14

2 14

Side 1 (J) Side 2 (K)

17

12

15

16

1

3

Face
Piece 1 (H)

6

7

12

10

5

9

8

1

3

18

11

18

19

17

19

Bottom
Body (G)

Face
Piece 2 (I)

5

11

8

2

4

Wing Weight 2 (B)

Wing Weight 1 (A)

Wing 2 (F)

Frog Body (B)

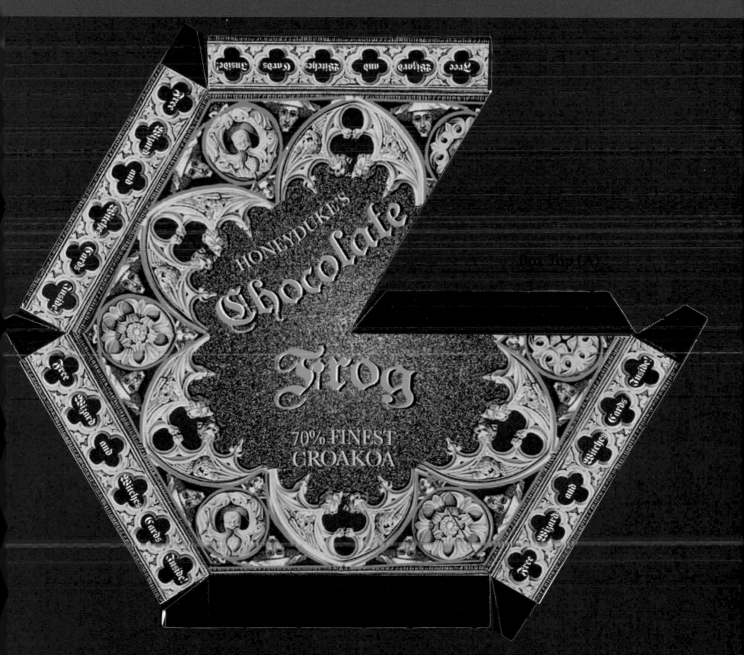

HONEYDUKE'S
Chocolate
Frog
70% FINEST
GROAKOA

Box Top (A)

Box Top
Tabs (T)

Free Wizard and Witches Cards Inside!

Free Wizard and Witches Cards Inside!

Free Wizard and Witches Cards Inside!

Chocolate Frog

Cocoa Solids 28% min
Milk Solids 25% min

45g

Honeydukes Chocolates Ltd.

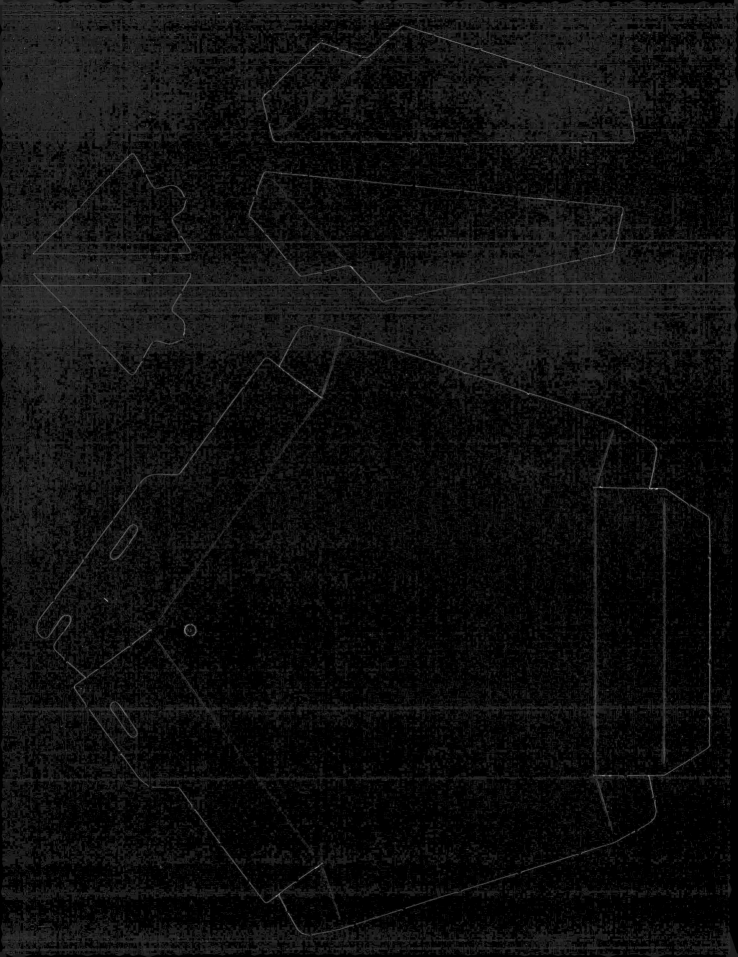

Flame Base (A)

Back of Goblet (B)

Back of
Flame (C)

Support
Wedge (D)

op-up Goblet of Fire

Stem Base (E)

Stem Decoration
Base (F)

Flame Tab (H)

Flame Tab
Support (G)

Goblet Base (I)

Pull Tab (J)

Goblet (K)

Flame Tab (L)

Pop-up Goblet of Fire

Tail (B)

Body (A)

Leg 1 (D)

Leg 2 (E)

Body (C)

Body (F)

Face (G)

Leg 1 (H)

Leg 2 (J)

Tail (Q)

Christmas Crackers Gryffindor

Feet/Tail (M)

Body (K)

Beak (L)

Wing 1 (N)

Wing 2 (O)

Head (P)

Christmas Crackers Ravenclaw

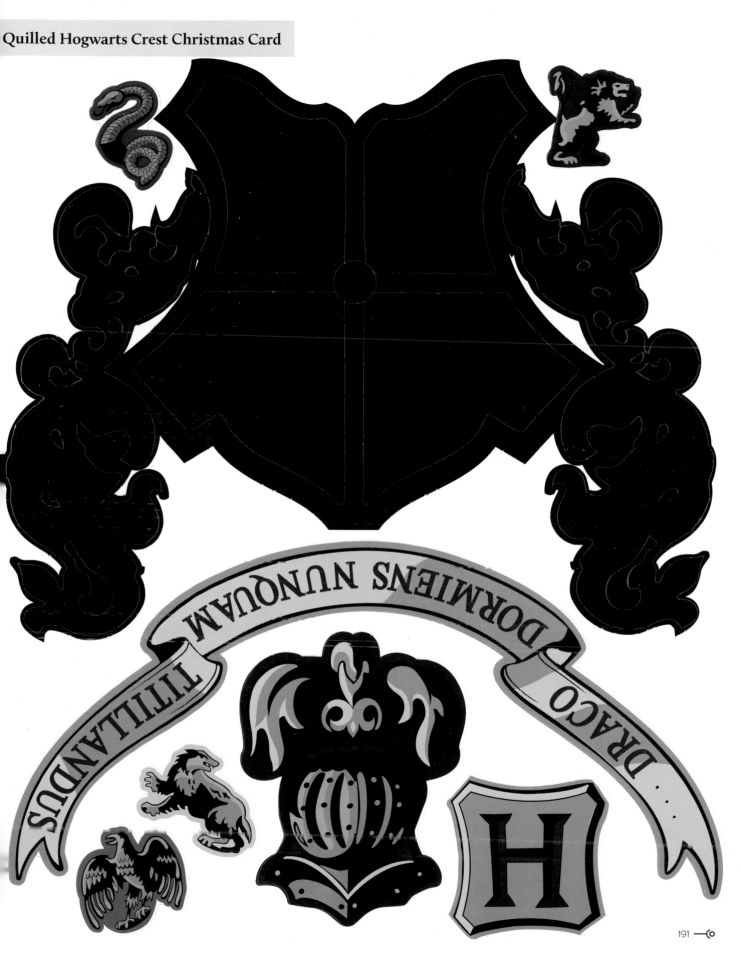

DIAGON ALLEY • LONDON

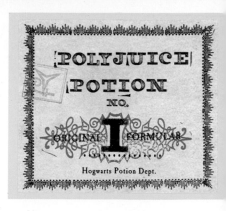

SKELE-GRO
FOR USE BY HEALERS ONLY

**INSIGHT
EDITIONS**

PO Box 3088
San Rafael, CA 94912
www.insighteditions.com

Find us on Facebook: www.facebook.com/InsightEditions

Follow us on Twitter: @insighteditions

Library of Congress Cataloging-in-Publication Data available.

ISBN: 978-1-64722-259-8

Publisher: Raoul Goff
VP of Licensing and Partnerships: Vanessa Lopez
VP of Creative: Chrissy Kwasnik
VP of Manufacturing: Alix Nicholaeff
Senior Editor: Greg Solano
Designer: Monique Narboneta
Managing Editor: Lauren LePera
Editorial Assistant: Anna Wostenberg
Senior Production Editor: Elaine Ou
Production Associate: Eden Orlesky
Senior Production Manager, Subsidiary Rights: Lina s Palma

Photography: Ted Thomas
Prop Stylist: Elena P Craig
Text by Jody Revenson
Additional craft design by Kirsten Winkelbauer

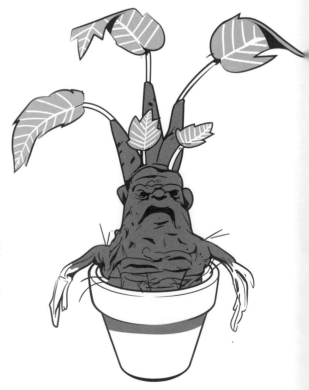

The publisher cannot accept any liability for injury, loss, or damage to any
property or user for following suggestions in this book.

ROOTS of PEACE REPLANTED PAPER

Insight Editions, in association with Roots of Peace, will plant two trees for each
tree used in the manufacturing of this book. Roots of Peace is an internationally
renowned humanitarian organization dedicated to eradicating land mines
worldwide and converting war-torn lands into productive farms and wildlife
habitats. Roots of Peace will plant two million fruit and nut trees in Afghanistan
and provide farmers there with the skills and support necessary for sustainable
land use.

Manufactured in China by Insight Editions

10 9 8 7 6 5 4 3 2 1